WEST WEST WEST

MAJOR PAINTINGS FROM THE ANSCHUTZ COLLECTION

FOREWORD BY PHILIP F. ANSCHUTZ
INTRODUCTION BY J. RICHARD GRUBER
TEXT AND ARTIST BIOGRAPHIES BY ELIZABETH CUNNINGHAM

THE ANSCHUTZ COLLECTION
IN ASSOCIATION WITH
UNIVERSITY OF NEBRASKA PRESS
DENVER, COLORADO

Cover
Alfred Jacob Miller, **Breaking Up Camp at Sunrise**

Research and Text: Elizabeth Cunningham

Editorial and Technical Assistance:
Mary Ann Ehlers, Martin Leuthauser

Design: Asher Studio, Denver, Colorado

Photography: Unless otherwise indicated,
by James O. Milmoe, Denver, Colorado

Plate #35: Malcolm Varon, New York, New York

Plate #36: Marc Glassman Photography, Palm Springs, California

Plate #75: Keith Seaman, Fresno, California

Printing and color separations:
Gritz-Ritter Graphics, Boulder, Colorado

Published by
The Anschutz Collection, Denver, Colorado

Distributed by
UNP University of Nebraska Press
Lincoln, Nebraska and London, England

Library of Congress Catalog Card Number 91-071392

ISBN 0-9629111-0-0

TABLE OF CONTENTS

The design elements chosen to decorate the catalog text are based on petroglyphs from the Hueco Sites in West Texas. Anthropologists rediscovered the rock art of the ancient Indian cultures in the nineteenth century. The motifs were then abstracted into the art of the nineteenth and twentieth century artists, both in painting and in ceramics.

The image of horse and rider used with the title indicates one of the first sightings of the white man. It signalled the arrival of the Spanish on the North American continent as recorded by the "early historic" Indian culture.

A cloud of mystery still surrounds the meaning of these petroglyphs. They project the western realm of the "Old Ones" in North America. Their exact dating is a matter of conjecture and will challenge future generations of artists and anthropologists for years to come.

ACKNOWLEDGMENTS

On behalf of The Anschutz Collection, I would like to extend our appreciation to the wonderful people who assisted with the production of this catalog:

J. Richard Gruber, Director of the Wichita Art Museum, wrote a thoughtful introduction on behalf of both his institution and of the museum directors of the United States tour venues. He and his staff provided the impetus for the printing of this catalog which was funded in part through the Forrest C. Lattner Foundation.

The Wichita Museum presentation of "Masterpieces of the American West: Selections from The Anschutz Collection" and related educational programming has been supported by a generous grant from the Forrest C. Lattner Foundation. Special thanks for Mrs. Martha Connelly for her support and encouragement of the distinctive outreach programs planned to make the Wichita presentation of this exhibition available to new and more diverse museum audiences.

Several museum colleagues generously shared their expertise and materials or assisted with the logistics: Richard Conn, Curator, Native American Department, Denver Art Museum, Denver, Colorado; Sandra D'Emilio, Curator, Museum of Fine Arts, Santa Fe, New Mexico; Kathy Clewell, Registrar, Palm Springs Desert Museum, Palm Springs, California; and Richard Ambrose, Curator of Art, Fresno Metropolitan Museum, Fresno, California.

With regard to research the staff at the Denver Public Library deserves recognition — in the Western History Department: Eleonore Gehres, Lisa Backman, Britt Kaur, Augie Mastrogiuseppe, Lynn Taylor, Phil Panum, Rose Ann Taht, Kay Wisnia and Nancy Chase; in Humanities: Jim Kroll and Judith Axelrad.

A hearty thank you to the catalog "workhorses"— Mary Ann Ehlers typed the manuscript and Martin Leuthauser assisted with technological details and the captions. Their help with the compilation, editing and proofreading of the text was essential in being able to meet our five-week writing deadline. Thanks also to James O. Milmoe for the majority of the photographic work; Connie Asher, Martha Carroll, Patricia Shurbet, Pat Grassfield and Merrill Mauk at Asher Studio for design and production; Jim Gritz, Sue Schneider, Judy Pagels and the wonderful production staff at Gritz-Ritter Graphics for color separations and printing. Cora Scherr and Patty Ballinger deserve mention here also. They were instrumental in supporting the Russian catalog, on which this volume is based.

My sincere appreciation to Philip F. Anschutz for supporting and believing in this project. His advice and his commitment were invaluable.

Thanks also to all of the wonderful personnel at The Anschutz Corporation for their support over the years, particularly Mary Ann Ehlers, Cora Scherr, Phyllis Murphy, Sandy Althaus, Nikki Evans, Jerry Matlick, Barbara Malott, Miles Williams, Rick Jones, Lou Molliconi, Pat Steinbach, Ches Culp, Mark Wagner, Tom Kundert, Craig West, Kenny Dawkins, Lynn Abromeit, Julie Hitch, Diane Edes, Bruce Kralovec, and Carolyn Van Eman. Risk Management, Accounting, Marketing and Ski Train departments also deserve a thank you.

My gratitude to Abbess Mary-Thomas Beil, O. S. B. and the Benedictine nuns of the Abbey of St. Walburga for their prayerful support and for providing the peace and solitude necessary for writing.

Finally a big thank you to my friends and my family who were long on patience and understanding and cheerfully endured my social absence. A special thanks to my husband and "unindicted co-conspirator," Terry Teis, for his unfailing love and support.

Elizabeth Cunningham, Curator
The Anschutz Collection

FOREWORD

When Thomas D. Nicholson, Director of
the American Museum of Natural History in New
York, spoke of The Anschutz Collection's place in
history, he stated that each painting "enables us to
look back and take a long view of the region, its
people, and our history." I consider art a wonderful
ambassador, providing one culture with unique
insights into the visual experience of another cul-
ture. Thus my desire to share the history and art of
the American West resulted in an extensive tour of
The Anschutz Collection from 1974 to 1991.
Exhibited throughout the United States, the exhibi-
tion "Masterpieces of the American West" was also
shown abroad in eight countries: Austria, Belgium,
England, Finland, France, Germany, the People's
Republic of China and the Soviet Union.

The Anschutz Collection is a natural out-
growth of my interest in history and love for the fine
arts. In assembling portrait, landscape and genre
paintings of the American West, I have sought out
works by important American artists who either
painted in the West or had an impact on the region's
portrayal. This focus has resulted in a comprehen-
sive survey collection which simultaneously blends
the visual history of westward expansion with the
development of American art.

Encompassing 160 years of Western history
and art, The Anschutz Collection features 185
American artists who depicted the West from early
exploration to modern time. The principle body of
works, however, begins in the 1820s with historical
portraits of distinguished Native Americans, like
Jesse Bushyhead by Charles Bird King, and ends in the
1940s with the blossoming of abstract expressionism,
shown in *Man, Bull, Bird* by Jackson Pollock.

From the days of the government surveys, suc-
cessive generations of artists depicted the overlap-
ping frontiers, capturing the events, locales, issues
and personalities important to the American West.
While the styles and media differ, the artists convey
the same message: the West is a beautiful, vigorous,
still untamed land whose spirit of adventure speaks
to all. Unquestionably, the course of American art
has been altered by its "Western experience."

Philip F. Anschutz

INTRODUCTION

First exhibited in April of 1974, "Masterpieces of the American West: Selections from the Anschutz Collection" concludes its national and international tour with this final scheduled presentation at the Wichita Art Museum. It seems appropriate that the tour ends in Wichita where Indians, traders, cattle drives and settlers converged during the nineteenth century as the western frontier advanced. Located on the original Chisholm Trail, Wichita was a crossroad of much of the cultural and artistic history reflected in the imagery of The Anschutz Collection.

Honored by the opportunity to serve as the hosting institution for the conclusion of the traveling exhibition, we have called this "The End of the Trail on the Chisholm Trail." This presentation, comprised of 81 paintings dating from 1836 to 1969, marks a return of the collection to our city. One of the earliest versions of the exhibition was presented in Wichita in 1975, soon after the tour began in the West. As a result, associations between The Anschutz Collection and Wichita have continued to the present.

The Anschutz Collection circulated during a period of flourishing public interest in the art of America and the culture of the American West. Concurrently, museum attendance grew and new museums and museum additions sprang up throughout the West. A new generation of scholars and curators are exploring and challenging both traditional theories and revisionist histories of the West. Since 1974, in every region of the country and in a diverse range of museums, The Anschutz Collection has been exhibited. It has contributed to this growing dialogue, bringing with it diverse opportunities to explore the art, culture and history of the evolving American West.

Philip Anschutz notes in his Foreword that the collection focuses on art produced in the years from the 1820s to the 1940s which depicts "the West from early exploration to modern time." Just as the works in his collection survey American art produced in these years, so does Wichita's history offer a microcosmic view of western urban development in these same years. Wichita serves, in many ways, as a representative western city. Its role in the development of the Old West, and its evolution into a modern city, adapting to the demands and opportunities of

the new West, mirrors the realities of many important western communities.

In 1836, four years after George Catlin traveled the Upper Missouri River and painted *Mandan Dance,* included in this exhibition, Jesse Chisholm led a party to the junction of the Arkansas Rivers. Chisholm, who was half Cherokee and half Scottish, led a group searching for gold, rumored to have been buried near the rivers by Spanish explorers. Earlier, in 1806, a member of the Zebulon Pike expedition camped here and noted the presence of Osage Indians. The site of the future city of Wichita was visited by members of the Stephen Long expedition in 1820, one year before the opening of the Santa Fe Trail, and by Kit Carson in 1827.

The land at the forks of the Arkansas and Little Arkansas Rivers, known to the Indians as *Ute-che-og-gra,* long served as a center for trade between the nomadic tribes of the Great Plains and the established tribes of the eastern regions. The Wichita Confederation, living in tepees and distinctive grass huts near the rivers, was joined by representatives from other tribes in supporting new trading posts here in the 1860s. From this location, Jesse Chisholm regularly traveled south into the Indian Territory where he advanced a significant trade business with James Richard Mead, a skilled buffalo hunter and trader.

By the time of Chisholm's death in 1868, most Wichita Indians had moved away to the Indian Territory. A city, bearing the name of the tribe, was incorporated in 1870. By 1872, soon after the railroad reached the city, the first great cattle herds, brought north over the trail named after Jesse Chisholm, arrived in Wichita. The city's boom days as a thriving Kansas cowtown had begun.

By the time of Wichita's emergence as a cattletown, Albert Bierstadt had traveled with the Lander expedition to the Rocky Mountains and had completed such important paintings as *Wind River, Wyoming* (1870). Thomas Moran accompanied the Hayden expedition to the upper Yellowstone River in 1871. His paintings and the photographs produced by William Henry Jackson played an important role in persuading Congress to designate the Yellowstone region as our first National Park in 1872. Five years before his trip to the Yellowstone

area, he painted *Children of the Mountains*. By 1877, when Dodge City replaced Wichita as the premier Kansas cowtown, James Walker completed his painting of ornately attired Mexican cowboys, *California Vaqueros.*

During the 1880s, while Wichita and other western cities developed as thriving centers of commerce and real estate activity, sheep ranchers and cattlemen fought range wars. In 1883, Frederic Remington, fresh out of Yale art school, arrived in Butler County, Kansas, less than fifty miles from Wichita, to operate his own sheep ranch. His experiences in Kansas and the contacts he made with authentic ranchers continued to inform paintings such as *Turn Him Loose, Bill!* (1892), painted long after he had returned to the East.

Charles Russell, also one of the most noted Western painters and sculptors, established his reputation after moving to Montana in the 1880s. While Russell developed his talents rapid changes occurred in the West. In 1889, parts of the Indian Territory were opened for settlement during the Oklahoma Land Rush. By 1890, the Indian Wars were concluded and, according to Frederick Jackson Turner, the days of the American frontier had ended. When Russell painted *The Scouts* in 1902 a new, romantic appreciation of the fading Old West was evident. In the same year, Owen Wister published *The Virginian* and the first western movie, *The Great Train Robbery*, was released.

As the Old West passed, the beginnings of a very different order emerged throughout the region. However, for some time the two seemed to exist side by side. Carry Nation, crusading for enforcement of the state's prohibition ordinance, contributed to the fame of artist John Noble when she damaged his nude painting of Cleopatra during her assault on Wichita's Carey House bar in December of 1900. For many, including Mrs. Nation, the days of brawling and drinking in permissive cowtowns had passed.

A new boom era developed soon after the discovery of oil in the nearby fields of El Dorado, Towanda and Augusta. Oil investors built large homes in the city's College Hill area and supported new ventures, including the fledgling aviation industry. Over the skies of Wichita new pioneers, including Walter Beech, Clyde Cessna and Lloyd Stearman, blazed trails quite different than those of Jesse Chisholm.

Clyde Cessna produced the first airplanes made in Wichita in space at the J. J. Jones automobile factory during the winter of 1916-1917. By 1927, Wichita was becoming known as "The Air Capital of the United States." Wichita's history echoed the pattern of other major western cities moving into the age of technology. Charlie Russell continued to paint images of the Indian and cattle cultures in the same years as Clyde Cessna's planes flew over the Kansas prairie. One year after Russell's death, Charles Lindbergh crossed the Atlantic in the "Spirit of St. Louis" and the "Woolaroc," built by Travel Air in Wichita, won the Dole race to Hawaii.

A school of artists emerged in the Santa Fe and Taos region during the opening decades of the century. The first major exhibition of the Taos Society of Artists was held in Santa Fe in 1913, the year of the Armory Show in New York. Charter members of the Taos Society of Artists, including Bert Geer Phillips, Ernest L. Blumenschein, Joseph Henry Sharp, Irving Couse and Oscar Berninghaus, are represented with important paintings in the current exhibition. During the 1920s, the arrival of Georgia O'Keeffe, John Marin, Stuart Davis and other masters of the modernist vision brought the most current trends in American painting to New Mexico and the region.

Art colonies began to appear elsewhere in the West. Beginning in 1919, a group of artists converged on the Colorado Springs area. Centered around the Broadmoor Art Academy, and nourished by Boardman Robinson's leadership, this colony flourished until the end of World War II. Many of the artists and teachers active with the Broadmoor Academy came from Kansas, including Birger Sandzen. Sandzen came from Sweden to teach at Bethany College in Lindsborg, Kansas. A number of artists gathered around Sandzen to live and work in Lindsborg. In his studio, at the end of 1930, the Prairie Print Makers held their first formal meetings, initiating a vital and active organization

which included a number of Wichita artists. Other art colonies and organizations appeared in California, Texas, Arizona and Iowa.

During the 1930s, as droughts and the impact of the Great Depression were felt in the western states, artists such as Thomas Hart Benton, John Steuart Curry and Grant Wood contributed to a new national stature for regionalist imagery. Subjects drawn from the Midwest and West were continually evident in their paintings, prints and drawings. Although acknowledged in the eastern art capitals, these artists returned to the heartland to teach and paint. Their theories and painting techniques were passed on to a new generation of American artists.

The American art world expanded in remarkable ways during the years from 1920 to 1940. Museums and art schools were built and expanded at unprecedented rates. Sixty new art museums were formed in the years from 1921 to 1930. Museums continued to open during the peak years of the Depression, especially in the West. The Wichita Art Museum, located on grounds trod by Wichita Indians only 70 years earlier, opened in 1935. Elsewhere, the Colorado Springs Fine Arts Center, and the Mary Atkins Museum of Art and the William Rockhill Nelson Gallery of Art opened during the same period.

The emergence of important art schools, staffed by nationally recognized artists, was one of the most important developments in the western art world in the period. Benton's *Wheat Threshing on the High Plains*, painted in 1969, depicts the type of imagery first popularized by the artist during the 1930s, when he taught his most famous student, Jackson Pollock. Pollock was born in the West and remained strongly influenced by his western upbringing even after he moved to New York. He carried the nationalistic concerns of the 1930s into the international environment of the Abstract Expressionist movement. *Man, Bull, Bird,* painted by Pollock in the period from 1938 to 1941, documents his merging of his of diverse styles and theories at the end of the Depression era.The tour of "Masterpieces of the American West: Selections from the Anschutz Collection" has made it possible for museum visitors throughout the United States and eight other countries to explore the enduring art and culture of the American West. For many viewers, including the thousands who visited the exhibition during its recent tour of the Soviet Union, this collection offered a unique opportunity to understand not only the culture of the West, but also the history and culture of the United States. On behalf of the many museum visitors who have seen this collection since 1974, and the many museums involved in the tour of the Anschutz Collection, I would like to thank Philip Anschutz for his generosity. And, on behalf of the Wichita Art Museum and the people of Wichita, I would like to thank him for the opportunity to present this final scheduled venue, "The End of the Trail on the Chisholm Trail."

J. Richard Gruber, Director
Wichita Art Museum

UNMASKING THE MYTH: THE DEEPER MEANING IN LITERATURE AND ART OF THE AMERICAN WEST

Like all regions of all nations, the western United States has produced a history which is in part an aspect of the larger national mosaic and is in part a singular entity. Regional history is a composite of local, national, even global factors that have merged, diverged, and recombined over time to form a distinctive, yet also a familiar pattern. The great challenge facing all regional historians is to analyze the particular while visualizing the universal, to render that which is unique while casting it in the proper and broader perspective.

Michael P. Malone
in *Historians and the American West*

Throughout the history of westward expansion, Americans have viewed the American West as a natural paradise, a land of opportunity and a place free of traditional conventions. For most Americans this vision still holds true. The West has become as much a part of the American dream as it is of the American mythos.

Poet Walt Whitman was describing the American West when he wrote about the pioneers crossing "that vast something, stretching out on its own unbounded scale, unconfined, which there is in these prairies, combining the real and the ideal, and beautiful as dreams."

Whitman also wrote: "I wonder if the people of this continental inland West know how much of first-class art they have in these prairies — how original and all your own — how much of the influences of a character for your future humanity, broad, patriotic, heroic and new?" (*Specimen Days*, 1892). The question arises: Why then has the culture, specifically here the literature and art, of the American West been dismissed as insignificant by critics and historians alike? The purpose of this essay is to address the historical reasons for the misconceptions about culture in the western states, and for the subsequent prejudices against the region's literature and art. The constraints in time and space limit this investigation to an overview, which includes in the first section a brief review of West's historiography. The second part of the essay is a pioneering effort to raise questions about and, hopefully, inspire further cross-topical investigation of the relationship between the literature and the art of the American West. It also cites parallels with the visual arts, in this case the painters of the American West. The

third part discusses in narrative form the various eras in the West's history and what role the artists played. (The artist biographies discuss the impact the region had on the artists in their time and space, and how that changed or influenced their work as well as how other artists or art historical trends affected them, and in some cases where paintings in The Anschutz Collection fit into the artist's oeuvre or body of work.)

It is important to note that part of The Anschutz Collection's mission in producing a travelling exhibition, that has been shown since 1974 throughout the United States, and in parts of Europe, The People's Republic of China and most recently, The Soviet Union, has been to dispel misconceptions and demonstrate that as a genre art of the American West has a significant place within the context of American art.

I

In 1990 the "New Western History," as the media terms it, received national notice in such publications as *Horizon, U. S. News and World Report* and *The New Republic*. In an article in *The New York Times Magazine*[1] Patricia Nelson Limerick and a number of other scholars throughout the West are debunking the myths of traditional western history, which Limerick sometime refers to as "old hat frontier history." She cites as an example a sentence from a standard textbook in the field, "The history of the America West is, almost by definition, a triumphal narrative for it traces a virtually unbroken chain of successes in national expansion." (*Westward Expansion: A History of the American Frontier* by Ray Allen Billington and Martin Ridge). This, Limerick states, is an example of the distorted and misleading, chauvinistic and sometimes racist and sexist, view of the West. It is a history which has been romanticized and elevated to heroic proportions. This mythic West was settled by rugged individuals, mostly white male, who brought democracy and civilization to the region. The real West, as present-day scholars like Vicki Piekarski point out, was "populated by all types of people, from all walks of life. It was not peopled by heroes and villains. The real heroes were ordinary men and women who built homes for their families and worked the land." [2] The West is typically portrayed with rose-colored glasses as the land of opportunity, which breeds

success. The long-standing romanticism and nostalgia about the region need, these historians say, to be balanced with the tragic, as the West was also the province of failure.

The reason for this sudden attention to the history of the American West is that the media and public are just beginning to notice the current status of research on the West. However, since World War II, western historians have been examining new methodologies and searching out new bodies of evidence. Until recently most historians have written about the nineteenth century since its history was so distinct and more manageable, rather than the twentieth century West which in its blending with national history, had lost its identity. Since then many historians have focused on the twentieth century West and have also published much of the current literature addressing ethnicity, women's issues and cultural topics. A noticeable increase in the volume of publications began in the 1980s, and by 1990 the changing attitudes reflected in those writings attracted national attention.

In *Historians and the American West*, Richard W. Etulain discusses the historiography of the West and its impact on culture in a chapter entitled "Shifting Interpretations of Western American Cultural History." The following discussion is based largely on his essay and the introductory essay by Michael P. Malone.[3]

Most of the early historians actively writing from the mid-to-late nineteenth century fit into the "local-history genre" of the age. Kathleen Neils Couzens described their work:

It [the local history] recounted a tale of progress and communal harmony in a conventional formula whose elements included surprisingly elegiac accounts of the Indians whom the community had dispossessed; heroic tales of the sufferings and achievements of the early settlers; chronological narrative of political and governmental milestones; recitation of the community's contributions to such national events as wars and economic crises; brief chronicles of the main economic, social, and cultural institutions of the town; and often a 'mug book' celebrating the lives of leading citizens.[4]

Hubert Howe Bancroft was the West's first historian of note. In the 1870s Bancroft and his research team began to collect source material for writing the histories of Mexico and the western United States. The resulting 39 volumes entitled *Works* today form the nucleus of the Bancroft Library at the University of California at Berkeley. These accounts are still valuable as reliable source material, offering the reader then as now detailed histories of the western states. In the writing of these volumes, Bancroft paid more attention to military, political and economic matters than he did to frontier literature or art. He also failed to examine the East's influence on the West, and neglected to mention the Mormon and Hispanic cultures entirely.

Frederick Jackson Turner (1861-1932) played one of the most prominent roles in shaping the West's historiographic tradition in the late 1800s. Turner delivered his key essay, "The Significance of the Frontier in American History," in 1893 to the American Historical Association's annual meeting in Chicago. Michael Malone summarizes Turner's thesis, which:

...argued that readily available land and the westering frontier worked over the course of three centuries to form a uniquely American character and civilization. Conceding the "germs" of European society were first rooted to the Atlantic Coast of the future United States, Turner argued that the leavening conditions of one semiwilderness frontier after another caused the Americans to shed some traits and to adapt others as they moved westward, until they had evolved an essentially new civilization.[5]

In Turner's view, the frontier experience also imparted distinctively American traits such as individualism, democracy and mobility to the nation.

Turner, like Bancroft, was more interested in the social sciences, particularly demography and geography, than he was in religion, education, literature or art. With regard to the West's cultural aspects, Turner expected no accomplishments in this arena, stating, "a primitive society can hardly be expected to show the intelligent appreciation of the complexity of business interests in a developed society." (Yet before Turner had even written his thesis in 1893, Bret Harte and Mark Twain had established themselves in San Francisco (1866) and Harte had been editor of a new magazine there, *The Overland Monthly*; the San Francisco Art Association had formed the West's first art school in 1874; and by 1875 universities throughout the West had been established!)

Turner was so popular and his theses so persuasive that his students and other historians adhered to the topics he emphasized. Additionally

most of his contemporaries were just as reluctant to deal with the West's cultural history. A case in point was historian Frederic Logan Paxson who in 1924 published the Pulitzer Prize-winning *History of the American Frontier, 1763-1893* (two volumes). While Paxson's work included full accounts of topics such as exploration and expansion, and economic and governmental developments, not one of his 83 chapters was devoted to cultural history.

Turner's legacy to western historiography stresses two main points: 1) an environmental interpretation sometimes approaching determinism, and 2) a preoccupation with the frontier. Turner's thesis was accepted by historians of the frontier from the 1890s until after World War II. By the 1950s, however, historians like Earl Pomeroy, Louis B. Wright and Henry Nash Smith began to question and object to the ideas of Turner and his associates. With the publication of *Virgin Land: The American West as Symbol and Myth* (1950), Henry Nash Smith changed the thinking and writing about the American West. His work helped revolutionize interpretations of the West and contributed the first monograph to what is now known as the American Studies movement.

In his work, Smith dealt with the myths of the West and demonstrated how these myths and such symbols as the Great American Desert and the Garden of the West were influential both to Turner and to Americans interested in the frontier. Along with government documents, dime novels, and historical books and essays that had been dismissed by other historians, he also examined the work of authors James Fenimore Cooper, Walt Whitman and Hamlin Garland to see what insights could be garnered from this previously overlooked material. Since the publication of *Virgin Land*, numerous western historians and scholars have based their research and analytic methodology on Smith's volume.

Since then western historians have pursued various in-depth studies within the scope of the region's cultural history, addressing issues in the arenas of women's and ethnic studies, religion, education, literature and art. These scholars have pioneered new fields of study and proven the importance of the West's history and its relation to the rest of the nation. They have finally turned the tide of the Turnerian thesis which asserted that the no culture of significance could arise from the American West.

II

Most Americans in the early 19th century gleaned their predominate impressions of the American West either from the accounts of people who travelled or settled there, or from European or American literature. Certainly literature has played an important role in shaping ideas about the West in the American mind. The earliest writings to impact the nation's public in the 19th century were the journals of the early explorers and mountain men.

The first journals from the government expeditions were those of Meriwether Lewis, Thomas Jefferson's private secretary, and Captain William Clark. Considered a "Renaissance man" by his contemporaries, President Jefferson's diverse interests were reflected in the instructions he gave Lewis and Clark with regard to their forthcoming exploration of the Louisiana territory. He asked them to conduct their expedition in a scientific manner, taking care to map the route, note the flora, fauna and the native peoples, the land with its soil and the natural resources. Further they were to treat the Indians well, but not at the expense of the expedition's safety. The resulting journals yielded a wealth of scientific data rich in botanical, zoological, and ethnological detail. Lewis and Clark conducted the first significant study of various Indian tribes, and Clark's study of the Shoshone, Sacajawea's people, is now considered a classic.

Nicholas Biddle was one of the first authors to publish material about the Lewis and Clark expedition. His two-volume work, *History of the Expedition Under the Command of Captains Lewis and Clark* appeared in 1814. This volume mapped the course for subsequent histories, some based on actual journals, of the early adventurers.

John Jacob Astor, who founded the American Fur Company in 1808, encouraged his friend, Washington Irving, to portray his fur-trading enterprises. Astor personally supervised his company's frontier posts which ranged westward from the Mississippi River to the coast of Oregon. *Astoria*

(1836) describes the territorial posts set in the land-scape of the Rocky Mountains and western Great Plains. A year later Irving wrote *The Adventures of Captain Bonneville, U.S.A.* which was based on the French fur-trapper's exploits on the Great Plains and in the Rocky Mountains. Irving himself embarked on an expedition to the West where he visited the Osage and Pawnee Indian nations. In *A Tour on the Prairies* (1835), Irving compiled his travel sketches from the journey, and created a memorable work that drew a brilliant picture of frontier life. John Francis McDermott praised Irving in his introduction to the re-issue of *A Tour on the Prairies* (1956):

> *Its perennial popularity owes much to the suavity, the geniality, the grace of expression which his critics have commonly allowed Irving, for the man could write as few of his contemporaries could. But the book is more than a literary exercise. Its true worth and its enduring fascination lie in the brilliantly drawn pictures of frontier life that flow from the pencil of a great genre artist.*

Irving's expedition coincided with George Catlin's journey to the Upper Missouri. Catlin's account, *Notes and Letters on the Manners, Customs, and Condition of the North American Indians* was published in 1841. Both men wrote about having the opportunity to see the animals and Native American inhabitants before, as Irving stated it, "they are driven beyond the reach of a civilized tourist." Thus Americans had an idea about frontier life from first-hand accounts, both written and visual, of the inhabitants and the landscape in the American West in the early nineteenth century.

While Washington Irving's work provided a true-to-life account of the American West, James Fenimore Cooper's work made a major contribution to the mythos of the West. He was concerned with the romantic aspects of the West that were derived from the ideals of such great French Romantic writers and painters as Rousseau and Delacroix. Cooper drew on the theme of primitive peoples who were, by their very simplicity, closest to God. Nature, the All of God became holy with the Indian as nobleman. In his *Leatherstocking Tales,* Cooper immortalized this theme and created idealized frontier types — the backwoodsman, the pioneer and the Indian — who would survive in the national consciousness for decades. His work set the precedent for the popular novel of the West that has lasted up to the present day.

The westering of America was another theme with which Cooper concerned himself. The continual westward movement was a major factor in the development of a mindset about the West. Known as both a land of extremes and of opportunity, it was a place that was by its very nature wild, remote, challenging and romantic. The works of Irving, Cooper and others describing the West fueled the American people's desire to experience life there.

In the nineteenth century hundreds of notable visitors from other countries came to the West for differing reasons: to study, to play and to observe. The German gentleman-scientist Alexander Philipp Maximilian, Prince of Wied-Neuwied, traveled with Swiss artist, Karl Bodmer, to the reaches of the Upper Missouri on an exploration among the Plains Indians in 1833-1834. (This is the same route artist George Catlin had travelled the previous year.) In the 1830s Scotsman Sir William Drummond Stewart trekked west on several occasions to hunt, and to attend the fur trappers' rendezvous. He hired artist Alfred Jacob Miller in 1837 to record his adventures. Viscount James Bryce, a noted English statesman and historian, made two trips in the 1880s to complete his book, *The American Commonwealth*, in which he stated that the West was "the most American part of America...the part where those features which distinguish American from Europe come out in the strongest relief."

While such realistic accounts of life in the West such as Maximilian's *Reise in das Innere Nord-America in den Jahren 1832 bis 1834* (1839-1841, later translated into English as *Travels in the Interior of North America from 1832 to 1834*) and Bryce's *The American Commonwealth* were available to the European public, a fictionalized West also emerged from that continent. The choice of the Native American as subject matter was a natural outgrowth of the German fascination with the "noble savage." In the nineteenth century, the Germans in particular, suffered from *Europa Müdigkeit* or European lassitude resulting from the social and political unrest of the time. This world weariness, coupled with German Romanticism, gave rise to the escapist literature that constituted much of nineteenth-century Germany's recreational reading. This popular fiction was based on the works of James Fenimore Cooper and the history and culture of the American West.

Two of the earliest German authors to write about the West were Charles Sealfield (1793-1864) and Friedrich Gerstäcker (1816-1892). Beginning in the 1820s, Sealfield published 18 volumes about the American Southwest based on his five trips to the United States. Friedrich Gerstäcker, whose first book *Steif und Jagdzüge durch die Vereignigten Staaten (Rambling and Hunting Trips through the United States)* appeared in 1841, wrote 150 volumes based on his three visits to the United States. Gerstäcker is often credited as the first author to write "pure" westerns. In his works he combines his actual experiences with outlawry in such books as *Die Flusspiraten des Mississippi (1848, River Pirates of the Mississippi)* to create a somewhat naturalistic image of the American frontier. Although Gerstäcker's works were considered inferior to Sealfield's, they were influential in promoting German emigration to the American West.

By far the most popular German author of the western genre was and continues to be Karl May (1842-1912). His 40 volumes of western lore have been translated into twenty languages, and since his death, the German public has purchased 45 million copies of his works. Read by people of nearly every social strata, his current estimated sales number one million volumes a year, and have reached such prominent personages as Adolf Hitler, Albert Einstein and Thomas Mann.

While May made several mistakes in the writing of his novels — for example, insisting that the tales were true-to-life accounts of his own adventures (when he had never been in the American West), and taking poetic license in attributing the Apaches as one of the most peace-loving Indian nations on the Plains, he did produce the formulaic "noble savage" and "Wild West superman" which still fascinate Europeans today.

Based largely on fiction, these writers created another mythos — the European epic version — of the American West. The resulting literature inspired artists like Heinrich Edouard Müller and Winold Reiss to travel to the United States and paint their versions of the West.

Echoing Europe, mid-century America's recreational readers were the target audience for publishers of popular fiction. In 1858 Erastmus and Irwin Beadle teamed up with Robert Adams to form New York's House of Beadle and Adams. Going on

the success of *The Dime Song Book,* the firm published the first novel under one cover that sold for a dime, hence the term "dime novel." The popularity and success of this undertaking was quickly illustrated by Edward S. Ellis' novel, *Seth Jones: or, The Captive of the Frontier* (1860). Almost instantaneously it sold 60,000 copies and was soon translated into six languages, which eventually increased the sales tenfold.

Rival publishers sprang up, and in answer to the competition, the editor-in-chief of the House of Beadle and Adams advised the company to "kill more Indians." These stories numbered 30,000 to 50,000 words and were a variation on a stock formula which emphasized action and inflated descriptions.

Not all dime novels were western, but the West as subject matter constituted the largest percentage of these stories. Western dime novels tended to avoid the darker issues that Cooper had featured in his novels, like the tragedy of America's total commitment to material progress. Instead they celebrated the doctrine of Manifest Destiny as reflected in the Percy St. John's *Queen of the Wood: or, The Shawnee Captive* (1868): "Never weary, never conquered, they advanced still onward toward the setting sun, laying first the foundations of home and then of empire."[7]

Much of this sentiment passed into both art and film genres. Emanuel Leutze's painting *Westward the Course of Empire Takes Its Way* (circa 1862, in the collection of the Thomas Gilcrease Institute of American History, Tulsa, OK) was in his words: "intended to give in a condensed form a picture of western emigration, the conquest of the Pacific slope..."

In filming Zane Grey's *The Vanishing American,* Paramount adapted some of Grey's other stories for the movie's prologue to visually depict the Indians preying upon each another, the stronger tribes annihilating the weaker ones, culminating in the white man's arrival, who in turn signaled to the strong race of surviving Indians that it was time for them to vanish. This reflected the concepts of "survival of the fittest" or social Darwinism prevalent at the time. Similar viewpoints were expressed in the work of Owen Wister and Frederic Remington. Social Darwinism went hand-in-glove with the ideas of Manifest Destiny, and is one of the issues most harshly criticized by today's historians.

In the 1870s Western heroes became even more idealized, and the standard theme in dime novels became that of redemption through the sacrifice of the wilderness to "progress." In the novel *Boone, the Hunter: or, The Backwoods Belle* (1873), "even Boone himself is characterized as a martyr to the advance of "civilization" (note: for progress and civilization... [substitute the words] materialism, greed, and destruction of the wilderness.)"[8]

In the late 1920s and throughout the 1930s, the dime novel had been replaced by Western pulp magazines. These in turn were superceded by Western romances and comic books in the 1940s and 1950s. By the 1960s the most popular characters in the Western comic books — Gene Autry, Hopalong Cassidy and the Lone Ranger — had been serialized for television.

Dime novels were considered "pulp" publications and were low-brow in comparison to "slick" publications like *Harper's Weekly, Ladies Home Journal* and *The Saturday Evening Post*. Among the first cowboy Westerns that Harper's published was a serialized edition of Owen Wister's work, including excerpts from *The Virginian*. The slicks and lesser publications like *Adventure, Argosy* and *Short Stories* featured writers of popular Western fiction like Zane Grey, Max Brand and Louis L'Amour as well as such literary figures as O. Henry, Jack London and Conrad Richter.

These works of popular fiction were generally formulary and Max Brand's description of the formula he used typifies most of the popular Westerns:

Action, action, action is the thing....The basic formula use is simple: good man turns bad, bad man turns good. Naturally there is considerable variation on the theme...There has to be a woman, but not much of a one. A good horse is much more important.[9]

The nation's major national publications, which were based in the East, were responsible for shaping a romanticized version of the American West. They dictated what the writers, and the artists who illustrated their stories, were to portray. Artist Maynard Dixon, born and raised in California, was so incensed at Eastern editors, who were telling him how to paint "his West," that he left New York where he had been successfully employed as an illustrator, and returned to the Southwest to paint.

The advent of television signaled the demise of most pulps and slicks, which were replaced by the paperback. Thus western popular fiction came full circle and was once again published under one cover as in the days of the dime novel.

The ideas most Americans have about the West come from television and films. There is therefore a tendency to identify all Western fiction either with the celluloid version of the West or with the popular works previously discussed. This is the main reason that historians, critics and the public have dismissed the region's entire genre.

Throughout the twentieth century writers have fought the prejudice against western literature. Mary Austin was infuriated by the narrow viewpoint of New York critics and chastised their tendency to ignore non-New York writers. Vardis Fisher wrote essays which attacked Eastern critics for failing to recognize the importance of western literature. John R. Milton author of *The Novel of the American West* (1980), wrote:

That Eastern readers and critics have dismissed the conventional Western novel is not nearly as important, or tragic, as the fact that they have lumped together all Western novels until they think no more of Harvey Fergusson, Frank Waters, and Walter Van Tilburg Clark than they do of Max Brand, Zane Grey, Owen Wister, et al. They have not understood that the West has just as good writing as the East, and that there is a tremendous difference between (Grey's) Riders of the Purple Sage and (Clark's) The Oxbow Incident. Even some Westerners do not understand this. And this misconception is precisely what I am trying to correct. I may fail. But it is about time someone tried.[10]

Just as Western fiction cannot be lumped into one category, the West itself cannot be considered as one uniform region. In *A Literary History of the American West*, the editors have divided the "Many Wests" into four geographical areas: the Far West, the Southwest, the Midwest and the Rocky Mountains. This allows the reader to see the differences in the landscape and people who lived there, and how each separate environment influenced the writers of that particular region.

In defining the meaning of regionalism in fiction, Mary Austin wrote in her essay "Regionalism in American Fiction,"[11] of her belief that were two requirements that an author must meet in regional

literature: 1) the region itself must be an integral part of the story, and 2) the story must be of the region, not about it.

Unbeknownst to many Americans, some of the West's writers were Pulitzer Prize winners, among them: Willa Cather (*One of Ours*, 1923), Oliver La Farge (*Laughing Boy*, 1929), John Steinbeck (*The Grapes of Wrath*, 1939), A. B. Guthrie (*The Way West*, 1949) and N. Scott Momaday (*House Made of Dawn*, 1969).

Willa Cather pioneered the writing about women's role on the Nebraska frontier in her two books, *O Pioneers* (1913) and *My Antonia* (1918). These works embody the pioneer women who overcame the challenges of harsh life on the prairie and feature strong female protagonists who do not require male heroes in order to succeed.

Oliver LaFarge had a lifetime interest and association with the Navajo nation. He chose to portray these people in *Laughing Boy* (1929) and this novel set a precedent for future realistic Indian novels. Owen Wister commented on LaFarge's work:

To choose Navajo Indians as your material, to exclude the white man, save as the merest accidental accessory, to depend wholly on a young Navajo lover and his mate — and to bring it off — is a most uncommon feat...a daring experiment, triumphantly successful.[12]

As were many other writers and artists, LaFarge was sympathetic to the customs and traditions of the Native Americans, but like them, he fought the misconceptions of the past. He lamented, "I've always found it difficult to get people to believe that Indians are like what they really are. James Fenimore Cooper's devastating work is too well done."

In his novel, *In Dubious Battle* (1936), John Steinbeck sympathizes with the poor working man. That book and his classic Depression work, *The Grapes of Wrath* (1939), established the author as a master of social protest literature. Steinbeck addresses the natural elements of the West which defeated the ordinary citizen during the Dust Bowl years. In both novels he features man as part of the natural order, who struggles against the elements of nature often manipulating them in order to survive.

Social protest was also expressed by artists during the Depression. George Biddle, who was instrumental in establishing the New Deal's Federal Art Program, did a series of lithographs at the Colorado Springs Fine Arts Center which depicted the devastation of the Dust Bowl. Alexander Hogue and Jerry Bywaters were among the Texas regionalists who painted and produced lithographs on the same subject,which echoed the plight of displaced farmers.

Raised in Montana, A. B. Guthrie fell in love with Montana's "big sky" country, which served as the setting in several of his novels. In *The Big Sky* (1947), a work about the rise and fall of the mountain man, the wide open spaces and big sky of the West serves as the unifying force, as it does in his other novels. In *The Way West* (1949), Guthrie gives a realistic account of the hardships the settlers endured in travelling the Oregon Trail. Based on extensive research, this true-to-life portrayal showed the tragedies of pioneer life and won Guthrie praise as a historical novelist. Guthrie said his work:

It has to be more than history faintly inhabited by figures. It has to be people, it has to be personalities, set in a time and place subordinate to them. Perhaps the hardest lesson for us historical novelists, as it is also the hardest lesson for any writer of fiction, is that it isn't event that is important; it is human and individual involvement in and response to the event.[13]

N. Scott Momaday was concerned about the place of the Native American in modern society. He was upset with the preconceived, stereotyped image of the Indian, and the fact that these notions set Native Americans apart from other men. He remarked, "None but an Indian, I think, knows so much what it is to have existence in two worlds and security in neither." In both *House Made of Dawn* (1968) and *The Way to Rainy Mountain* (1969), Momaday portrays the Indians as human beings caught between two cultures. Set in the twentieth century, *House Made of Dawn* depicts the conflict between the "old ways" of the Indian culture and the problems of urban, relocated Indians in the city. *The Way to Rainy Mountain* attempts to share Kiowa folklore and legend and Momaday's own memories in order to immerse non-Indians in the Indian experience.

III

Alongside the literature which fired the American imagination about the West, artists provided another record of westward expansion in The United States. While no artist accompanied the Lewis and Clark expedition of 1803, subsequent government explorations, beginning with the Long Expedition in 1820, employed artists to produce visual documentation to augment the written reports. Thus began a tradition unique to the westering of the United States in the Jeffersonian age. As each era of expansion unfolded, artists were present to document the successive and overlapping frontiers, many of which would have been otherwise lost to historical depiction.

The painting of the early explorer artists conveys the wonder they experienced in charting the New World's wilderness with its indigenous flora and fauna and native people untrammeled by civilization. These early artists carefully chronicled every detail of what they observed.

Around the time that the first expeditionary artists were recording the Long Expedition of 1820, Charles Bird King was painting the portraits of important personages from Indian delegations visiting Washington, D. C. on official business. This body of work was commissioned by Thomas McKenney, head of Indian affairs, who later hired portraitist Henry Inman to copy them. The Inman renditions were then translated into lithographs and used in the book of Indian biographies which McKenney later published.

George Catlin saw these same Indians as they passed through Philadelphia on their way to the nation's capital. His sense of history compelled him to go west of his own volition. He wanted to capture the Indians' way of life before civilization obliterated it. As Catlin thought that the Indians had no spokesmen of their own, he appointed himself their biographer. He travelled up the Missouri River in 1832 and captured the Mandan tribe on canvas.

(This was a fortunate historic stroke, for the Mandans were nearly decimated by smallpox just 5 years later.) By 1840 Catlin had painted nearly 600 pictures, recording over forty Indian nations.

Alfred Jacob Miller was among the first European-trained artists to go west. In 1837 he was hired by adventurer and hunter Sir William Drummond Stewart to record the latter's hunting expedition at the annual fur trappers' rendezvous. Miller was the only artist to witness and record this boisterous event where trappers, Indians and traders met in the Green River area of Wyoming to exchange goods for furs and carouse in the process.

By mid-century the land from the eastern seaboard west to the Mississippi had been civilized and cultivated. A national consciousness was emerging that connected the spirit of discovery and manifest destiny. In art this was reflected as famous early day explorers were elevated to heroic stature. Daniel Boone, the "Pathfinder" responsible for leading settlers across the Appalachian Mountains into Kentucky, reached epic proportions both in literature and in painting, much like a character from Cooper's *Leatherstocking Tales*.

William Ranney depicted Boone with his legion of fellow explorers pointing off to the allegorical promised land. Westward lay the land of opportunity for anyone courageous enough to face the dangers of the wilderness and the threat of the often fierce Native Americans who inhabited the land.

The American dream of westward continental expansion awakened a desire in American artists to celebrate the wilderness. An indigenous school of landscape painting emerged, characterized by a penchant for the picturesque. Hudson River School artist, Asher B. Durand, reflected the sensibilities of the day in his writings. He believed that landscape painting glorified God and that the artist was bound to represent the works of God through the study of Nature. In the grand scheme, as evident in his painting, *Indian Rescue*, the human drama is insignificant, overshadowed by God and Nature. A few decades later this romantic sentiment was translated in part to the landscape painting of the American West by Bierstadt and Moran.

The acquisition of the Oregon (1846) and California (1848) territories lured settlers to the Pacific Coast. With the discovery of gold in California in 1848, adventurers flocked to the West to seek their fortune. Artists also tried their hands at prospecting, but soon found that painting panned out better than mining. The western paintings of Albertus del Orient Browere are considered among his best. His delightful *Gold Miners* recounts his experiences in the California mining camps.

A decade after the gold rush, the government sent an expedition to chart the route for an overland passage to the California coast. Albert Bierstadt accompanied the government survey party led by Frederick Lander in 1859. He matched the awe-inspiring vistas of the Rocky Mountains with monumental paintings that were themselves panoramic spectacles. The foremost landscape painter of the 1860s, Bierstadt presented the public with a romanticized view of the West which even the critics found breathtaking.

In 1871 Thomas Moran, along with photographer William Henry Jackson, travelled to the Yellowstone region with Ferdinand V. Hayden's geological survey team. Moran, like Bierstadt, was noted for his dramatic use of color, his desire for grandeur in landscape paintings and for idealization of the landscape. He felt that an artist was obligated to produce for the viewer the impression produced by nature on the artist. The brilliant hues of Moran's watercolors, depicting the wondrous land of steaming geysers, bubbling mud pots, cascading waterfalls and lofty summits of igneous rocks greatly impressed the United States Congress. The artist's paintings, combined with Jackson's photographs and Hayden's geological reports, convinced the legislature to designate Yellowstone as the world's first national park.

The monumental canvases of Bierstadt and Moran encouraged eastern editors to send artists west on assignment. *Harper's Weekly* magazine, as a result of subscription wars with *Frank Leslie's Illustrated Newspaper,* sent Jules Tavernier and Paul Frenzeny on an expedition. Their journey commenced on the Atlantic seaboard and ended on the Pacific coast. They travelled along the route of the transcontinental railroad, which had been completed in 1869, and sent sketches back to the East for lithographers to translate for the printed page. Tavernier and Frenzeny's pictorial records provided the eastern public with a visual account of the West that was unavailable elsewhere: eyewitness accounts of the towns, of the emigrants' lives, of Indian troubles and other incidents of western life.

Later other magazines continued to send artists west to gather fresh material related to the region's progressive unfolding and settlement. While the earlier illustrators had presented the Eastern populace with first-hand accounts, the demise of the "wild" West caused public demand for a reenactment of past events. To meet public demand, the illustrated journals of the day hired illustrators to interpret the Old West. Over the years a romanticized version replete with archetypical characters emerged, which favored the legendary over the real West. In 1890 the United States Census Bureau had declared the closing of the frontier. With its closing, two of the West's best-known artists, Charles Russell and Frederic Remington, scrambled to relate the last vestiges of the frontier West.

Dubbed the "Cowboy Painter," Russell rode the range and wrangled horses. His portrayals provide an intimate and realistic view of ranch life. He depicted cowboys in everyday situations — lassoing and branding cattle, rounding up the *remuda* (string of horses) — and the awkward positions they often got themselves into. For example, when the rope gets tangled up between the cow pony and the steer at the other end, or when a bronco bucks into the midst of the camp cook's domain and sends the victuals flying. Russell's paintings fostered the cowboy's ascent to the realm of folk hero. The artist also lived among the Blackfeet Indians, sharing their camps and their customs. He captured scenes on canvas ranging from the brave deeds of the warriors to tender moments in Indian courtship to the squaw holding her papoose outstretched above her to greet the sun at dawn.

Frederic Remington tried his hand at sheepherding near Peabody, Kansas and running a saloon in Kansas City before beginning his career as an illustrator. Like Catlin and countless other artists before him, he witnessed and mourned the passing of an era. He watched as the land became cultivated and towns emerged to replace the wild and woolly West he had known. The most famous of all illustrators of the frontier West, Remington became its spokesman. He created a mythos around fierce Indians, picturesque cowboys and splendid soldiers whose free and hard-riding way of life was brought to a sharp halt with the advent of the barbed wire fence and the end of the open range. Together with two other Easterners — Theodore Roosevelt and Owen Wister — Remington helped shape concepts about the West such as freedom and independence, and rugged individualism and self-reliance. These

qualities are indelibly etched on the minds of Americans regarding the West even today.

In the 1880s and 1890s William F. "Buffalo Bill" Cody presented the United States and the European continent with his Wild West Show. His particular vision preserved the spirit of the frontier West with a unique blending of legend, drama and history. The show reenacted events from Western life and history and encompassed Indian war dances, the pony express, buffalo hunts, the Custer Battle and ranch life. Later new elements involving horsemanship were added: Mexican vaqueros and Russian cossacks joined the "Congress of the Rough Riders of the World." Buffalo Bill made some of his own films of his Wild West Show. His films and Wild West Show, and the paintings of Remington and his contemporaries, provided subsequent movie makers with a popular vision of the West that they broadcast worldwide.

The nineteenth century closed with the Spanish-American War. By then western states had been settled and delineated by the borders that define them today. The new century saw the rise of the middle class which had more leisure time and expendable income. In response to this, W. H. Simpson of the Santa Fe Railway devised a brilliant advertising scheme,which combined tourism and art to promote the railroad. He commissioned artists to paint the Pueblo Indian festivals and dances, the desert landscape, and natural wonders like Monument Valley and the Grand Canyon. Artists received free passage plus room and board from the railroad in exchange for paintings of the Southwest. The art works decorated the railway stations, while reproductions appeared on calendars, brochures and posters promoted passenger service and tours to the Southwest. William R. Leigh captured the vivid hues of the Grand Canyon while Oscar Berninghaus, LaVerne Nelson Black and Simpson's favorite artist, Eanger Irving Couse, depicted the Indian ceremonials.

Around the turn of the century urbanization and changed societal values, resulting from mass production and commercialism, caused artists to migrate to rural areas. There they established art colonies. They sought fresh material and exotic subjects that were rooted in the traditional native life of America. The pristine unsettled area around Santa Fe and Taos, New Mexico met these requirements. Colorful Indian and Hispanic people, characterized by their unfamiliar rituals and native crafts, resided in adobe pueblos and town plazas. They populated a land equally distinctive for its red sandstone soil and its topography which ranged from desert to mountain terrain.

In 1898 New York artists Ernest Leonard Blumenschein and Bert Geer Phillips made the fabled painting excursion that founded the art colony in Taos, New Mexico. Other artists soon followed, drawn by both their acquaintanceship with Blumenschein and Phillips and the attraction of the varied landscape and native peoples. Due to the remoteness and inaccessibility of Taos, the art market there was limited. Thus the Taos Society of Artists was formed to promote and sell the members' paintings through a cross-country circuit. In 1918 and 1919, for example, works by Blumenschein, Phillips, Henry Sharp, Walter Ufer and Victor Higgins were exhibited in New York, Chicago, Kansas City, Denver, and Los Angeles. Consequently, through the efforts of the members of the Taos Society and the Santa Fe Railway, both the East and West coasts were repeatedly exposed to paintings of the Southwest. These canvases attracted public attention similar to the earlier expositions of Bierstadt and Moran.

In the second decade of the twentieth century, nationally renowned eastern artists visited the area around Santa Fe and Taos. In contrast to the first generation of painters whose pictures were primarily academic, the second generation of artists painting in New Mexico were advocates of modernism. The imagery, light and color of the Southwest provided the perfect vehicle for experimentation with innovative approaches to abstract painting. Most of these artists enjoyed a new vitality in their painting as a result of their New Mexico experience.

In 1916 Robert Henri, leader of The Eight (a New York group of Modernist painters), journeyed to Santa Fe at the behest of his friend, ethnologist Edgar Hewett. Hewett felt that Henri could make a valuable contribution to the art colony there. Fellow New Yorker, George Bellows, met Henri on this trip and together they painted the Indian villages and the environs of Santa Fe. In response to the light and color of the region, Henri lightened his palette. He also began to use design elements from Indian costumes in his portraits.

Henri returned to Santa Fe the following summer, joined by George Bellows, Paul Burlin and Leon Kroll. Other artists from the East, inspired by Henri's account of his southwestern sojourn, made subsequent trips. John Sloan, another member of The Eight, and his contemporary, Randall Davey spent the summer of 1919 painting in the environs of Santa Fe. Inspired by the brilliant desert light, the ever-changing atmospheric conditions and the colorful inhabitants, Sloan and many of his fellow artists experienced renewed vigor in their work, which was noted in exhibitions in the East.

By the time Henri and Sloan visited New Mexico, both men had been instructors at the Art Students League in New York, and had published books on their philosophies of art. Besides importing modernist trends and ideas, they had an additional impact on the Santa Fe art community. At the request of Edgar Hewett, who became director of Santa Fe's new art museum, Henri served in an advisory capacity and helped set policy. Sloan later assisted in maintaining the policy set by Henri. Both artists also took part in and helped organize art exhibitions, and were supportive of the artists living in Santa Fe.

In Taos, other modernists began visiting at the invitation of socialite Mabel Dodge Luhan. In 1913 she had established her own salon in New York. Her Thursday nights were famous for attracting the intellectuals and artists of the *avante garde*. Mabel first came to Taos in 1917, persuaded by her then-husband, artist Maurice Sterne. She considered Taos her spiritual home and fell in love with its mystique. The religion of the Pueblo Indians fascinated her and she wished to absorb their spirituality. To this end she eventually married Tony Luhan from the Taos Pueblo. Eager to share her mystical experiences, Mabel Dodge wrote several books.

She was responsible for luring such luminaries as Carl Jung, writer D. H. Lawrence, poet Carl Sandburg, and a score of artists to Taos. Andrew Dasburg and Marsden Hartley were the first to visit in 1918. Georgia O'Keeffe and John Marin were Mabel Dodge's guests in 1929. Each of these artists was profoundly affected by their experience in the Southwest. Marin produced over one hundred paintings from the two summers he spent there. Hartley later painted a series based on his memories of the region's landscape. Georgia O'Keeffe and Andrew

Dasburg eventually settled in New Mexico.

Perhaps the most renowned painter of New Mexico, O'Keeffe attracted the greatest attention over the years. Her series of flowers, sun-bleached bones, adobe churches and red hills planted southwestern motifs in the minds of the American public. Dasburg, however, played a more integral role in the art community. He had been a teacher at the famous art colony in Woodstock, New York before coming to New Mexico. When he moved to Taos, he attracted disciples and students from the East. Dasburg's theories and techniques influenced the work of resident modernists for many years.

The remote and exotic environs of New Mexico also attracted immigrants to the area. In the 1920s two Russian artists journeyed to New Mexico, each on account of poor health. Leon Gaspard came to Taos to recover from war wounds suffered in France. He was fascinated with the Pueblo Indians who reminded him of native peoples he had visited and recorded in his own country. Nicolai Fechin traveled to Taos in 1927 on the advice of his doctor (and at the invitation of Mabel Dodge Luhan). He was enchanted with the landscape which reminded him of the Caucasus. The New Mexico inhabitants were reminiscent of his native Kazan with its many tribes and cultures. Both artists created vibrant canvases in response to the light and color of New Mexico.

Many western states' artists were involved in mural painting in the 1930s and 1940s. In the 1930s the United States was in the throes of the Great Depression. In response to the dire economic straits of the nation, President Franklin D. Roosevelt created the New Deal in 1933. Under this program the Federal Art Project provided government-sponsored economic work relief for artists.

From its inception until its phase out due to World War II, the Federal Art Project commissioned over 4,000 public works of art for schools, post offices and other government buildings. Most murals were painted in a romantic and illustrative style. The subject matter reflected the local community and drew regional history and events. Colorado-born artist Fletcher Martin chose a typically western subject, the rodeo, and depicted steer wrestling in his mural study, *July 4th, 5th and 6th.*

After World War II many of the artists who had begun their training under government-spon-

sored programs achieved their own prominence. Jackson Pollock was involved with the Federal Art Program from 1935 to 1942. His paintings draw on a childhood spent in the West and his exposure to the crafts and rituals of Native Americans. He used totemic images in his early paintings like *Man, Bull, Bird.* In his later abstract works, his drip technique was inspired by Navajo sand painters.

In the 1950s and 1960s pop art dominated the scene in reaction to abstract expressionism. Art critics and academics alike favored abstract painting and condemned the representational mode. In the West, the land and nature are predominate features which lend themselves to realism. Although these aspects can also be expressed in the abstract mode, the realist mode is traditionally more prominent in portraying the West. Many of the artists continued painting representational pictures of the region and because of this, their work fell out of favor.

In the 1970s representational art regained its former status, opening the way for new expressions within the tradition. A new direction of American Indian painting emerged, pioneered by Fritz Scholder. He broke with tradition. Instead of painting stereo-

typical Indians like the past century's "noble savage," he painted them in the context of the twentieth century. He depicted the social and psychological dilemmas facing modern-day Native Americans, caught between their traditional way of life and mainstream American culture. Scholder's work characterizes the kind of vision shared by many contemporary painters working in the American West.

Modern day artists continue to present the cultural diversity of the people, and the power and energy of the land. Like their nineteenth century predecessors, twentieth century artists are finding a wealth of fresh subject matter. Today's American West still boasts land where cowboys ride the range, as often in pickup trucks as on horseback. National Parks preserve wilderness areas that the early nineteenth century artists portrayed. Optimism, hospitality and freedom from traditional conventions are attributes that still identify the Westerner. The West remains, today as in the past, a land of contrasts and contradictions, where legend and reality meld to become one in the American consciousness.

Elizabeth Cunningham

1. Richard Bernstein, *New York Times Magazine*,"Unsettling the Old West: Now historians are bad-mouthing the American Frontier," March 18, 1990, pp. 34, 56-57, 59.

2. Jon Tuska and Vicki Piekarski, *Encyclopedia of Frontier and Western Fiction*, p. XVII.

3. Michael P. Malone, editor, *Historians and the American West*, pp. 415-432.

4. *Ibid*, p. 4.

5. *Ibid*, p. 5.

6. Jon Tuska and Vicki Piekarski, *Enclopedia of Frontier and Western Fiction*, p. 189.

7. Tuska and Piekarski, p. 273.

8. *Ibid*, p. 273.

9. *Ibid*, p. 278.

10. *Ibid*, p. 239.

11. *English Journal* (vol. XXI, February, 1932) in Jon Tuska, *The American West in Fiction*, p. 25.

12. Tuska and Piekarski, p. 207.

13. *Ibid*, p. 144.

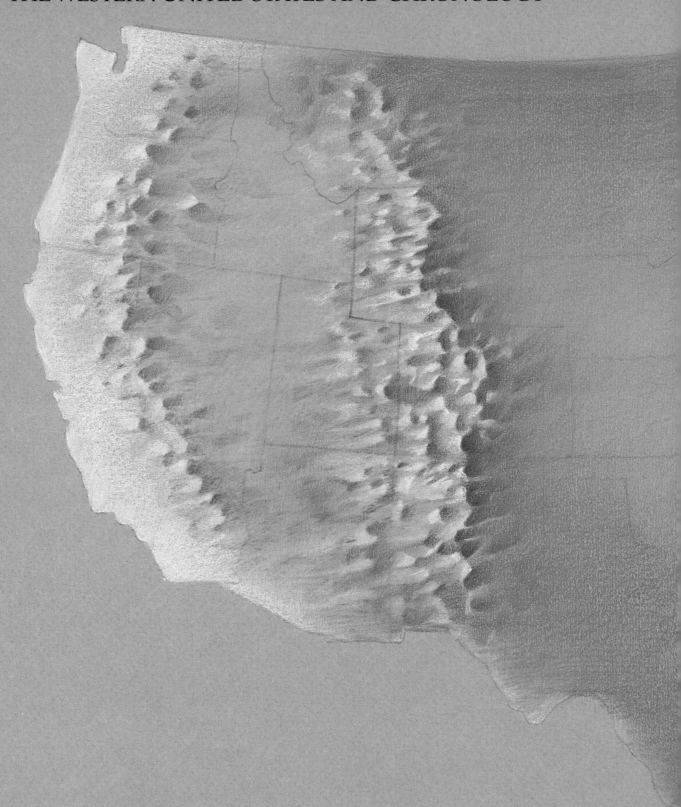

1804 -1806	Lewis and Clark explore Louisiana Territory and Pacific Northwest.
1824 -1838	American Fur Company holds yearly rendezvous in Wind River Mountains, Wyoming.
1832	George Catlin journeys to St. Louis and the Missouri Territory to record Native American tribes.
1835 -1836	Texas Revolution.
1837	Sir William Drummond Stewart retains Alfred Jacob Miller to record the American Fur Company rendezvous on the Green River, Wyoming.
1848	Start of California Gold Rush.
1850s	Wagon roads built. United States Government inaugurates stage coach travel.
1858	Pike's Peak Gold Rush.
1859	Albert Bierstadt joins government expedition commanded by General Frederick W. Lander to survey overland wagon route from Ft. Laramie, Wyoming to the Pacific coast.
1860	Inauguration of the Pony Express.
1861-1865	Civil War.
1862	Homestead Act. First act providing inexpensive land to settlers.
1866	Start of large-scale cattle industry.
1869	Completion of the transcontinental railroad at Promontory Point, Utah, joining the Union Pacific and Central Pacific Railroads.
1871	Thomas Moran travels to the West with government expedition to upper Yellowstone River. His paintings help influence Congress to establish Yellowstone as world's first national park.
1880	Charles Russell travels to Montana to work on ranch.
1881	Frederic Remington begins pictorial account of the West.
1886 -1887	Disastrous winter ends open-range phase of cattle industry.
1889	Oklahoma Land Rush.
1889 -1891	Ghost Dance and Wounded Knee end government wars with Native Americans.
1890	Census Bureau declares the closing of the frontier.
1898	Ernest Blumenschein and Bert Phillips arrive in Taos, New Mexico, and help establish art colony.
1904	N. C. Wyeth and Frank T. Johnson travel to Colorado on magazine commission to experience and sketch life in the West.
1915	Taos Society of Artists organized. Blumenschein, Phillips, Sharp, Couse and Berninghaus are charter members.
1917-1918	United States participation in World War I. Need for raw materials to supply military spurs western economic growth.
1920s	Agricultural overproduction, mining decline cause depression in West before stock market crash of 1929.
1924	Venice Bienniale includes works by Berninghaus, Higgins, Blumenschein, Couse, Ufer and Hennings.
1929	John Marin, Georgia O'Keeffe, and Marsden Hartley spend summer months in Taos, New Mexico.
1930s	The Great Depression.
1933	Franklin D. Roosevelt's New Deal policies transform the West.
1935 -1940	Federal Arts Project awards art commissions to Jackson Pollock, Fletcher Martin, Emil Bisttram, and most of Taos Society painters.
1939	Blumenschein, Berninghaus, Bellows and Benton have paintings in New York World's Fair.
1941-1945	United States participation in World War II pulls country out of Great Depression.
Post-1945	After war, the West continues to profit from strong government undertakings resulting in technological development of light industry.
1950s	Advent of Abstract Expressionism.
1964	Congress establishes Wilderness Act.
1970s	Re-emergence of realism as accepted painting mode. Fritz Scholder paints Indian series.
1973	Confrontation between Native Americans and United States Government at Wounded Knee, South Dakota.

CHARLES BIRD KING

(NEWPORT, RHODE ISLAND 1785-WASHINGTON, D. C. 1862)

King received his first formal art instruction in New York City under Edward Savage. In 1806 he journeyed to London to study under Benjamin West at the Royal Academy. King returned to Philadelphia in 1812 where he began his professional career. In 1818 he moved to Washington, D. C. There he came to know and later paint portraits of some of the nation's prominent personages, among them President John Adams, Secretary of War John Calhoun and inventor-statesman, Benjamin Franklin.

His portraiture came to the attention of Thomas L. McKenney, chief of the Bureau of Indian Affairs, who commissioned King to paint the portraits of over one hundred members of various Indian delegations who visited the nation's capital from 1820 to 1830. He was the first artist to systematically record the American Indian and the resultant Indian portrait series brought him early recognition and permanent fame. His work formed the nucleus of the War Department's Indian Gallery collection which was destroyed in the Smithsonian Institution fire of 1865. Fortunately, however, over forty of his other Indian portraits survive and are preserved in public and private collections throughout the United States. As with Catlin, Miller and other artists who captured eras in the West, King's record of the Native Americans in the early days of the Republic preserved the characteristics of a people for the history of the nation.

Trained in the classical tradition, King depicted his subjects in a manner that was realistic without being sentimental. His portraits evidence a sympathetic study of Indian character as seen in *Jesse Bushyhead* (1828). He captures the essence of the Cherokee statesman known for his intelligence, wisdom and eloquence. Bushyhead was an important leader of the Cherokee tribe, one of the largest and most powerful Indian nations in North America. An ordained Baptist minister, he served his people as a diplomat and as an interpreter. Respect for him was so great that he was the only official who could ride anywhere on Cherokee land armed with only a Bible.

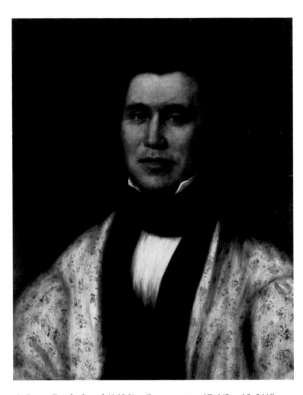

1. *Jesse Bushyhead* (1828), oil on canvas, 17-1/2 x 13-3/4"

GEORGE CATLIN

(WILKES BARRE, PENNSYLVANIA 1796-JERSEY CITY, NEW JERSEY 1872)

Originally trained as a lawyer, George Catlin resolved to become an artist while still a student. In 1824 he was profoundly impressed by a delegation of Indians passing through Philadelphia. He decided then that the Red Man would become both his subject and his cause. His journal conveys his determination and dedication to his self-imposed project: "The history and customs of such a people, preserved by pictorial illustrations, are themes worthy of the lifetime of one man, and nothing short of the loss of my life shall prevent me from visiting their country, and of becoming their historian." His journals and paintings provided one of the most important records of the trans-Mississippi West before the advent of the settlers.

In 1832 he began his long-planned trek up the Missouri River to Fort Union on the maiden voyage of the the American Fur Company's steamship, the "Yellowstone." Catlin spent 86 days on the Upper Missouri. During this time he observed buffalo hunts and important tribal ceremonies such as the buffalo dance and the manhood rites of the Mandan Indians.

Nine years later, Catlin published *Letters and Notes on the Manners, Customs, and Conditions of the North American Indians*. With this volume, the artist became one of the earliest historians for these tribes. Over time this work has proven an invaluable resource, providing records about a people that otherwise would have been lost. A case in point was the Mandan tribe which was nearly decimated by smallpox in 1837, just five years after Catlin captured them on canvas.

Catlin can also be credited with the earliest "Wild West Shows" featuring performances by Native Americans in Europe. Throughout the 1840s, he circulated over 400 portraits, landscapes and scenes depicting Indian life in Great Britain, France, and Belgium.

The *Bull Dance* (1832), part of the Mandan *O-kee-pah* ceremony, was observed annually to ensure the coming of the buffalo, the Indians' main food source. *Mystery Lodge* (1832) depicts the medicine or mystery-man as he invokes the Great Spirit on behalf of the initiates about to undergo the sacred torture ceremony. *Mandan Dance* (1832) portrays "the last race," the final ordeal of the manhood rites.

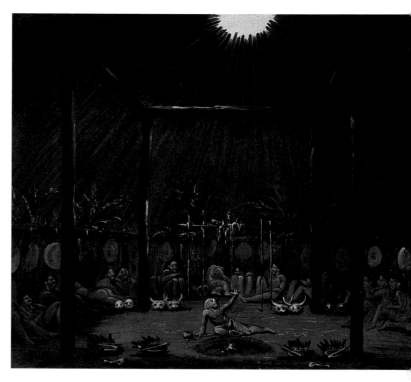

2. *Mystery Lodge* (1832), oil on canvas, 23 x 27-3/4"

3. *Bull Dance* (1832), oil on canvas, 22-3/4 x 27-3/4"
4. *Mandan Dance* (1832), oil on canvas, 23-1/2 x 28-1/4"

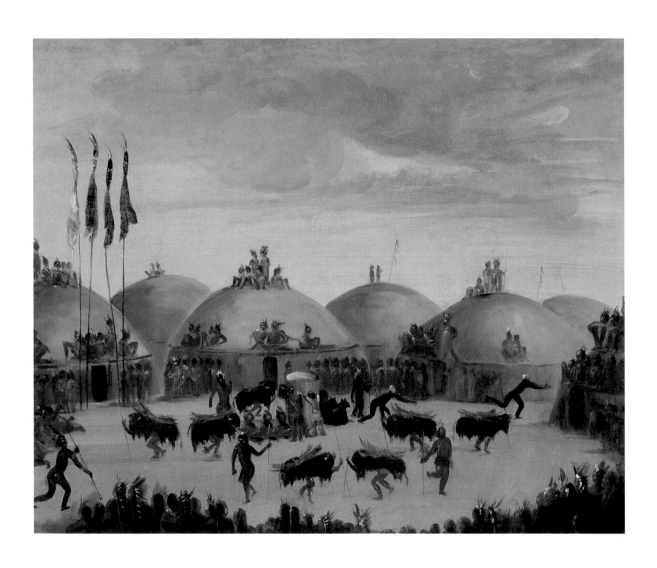

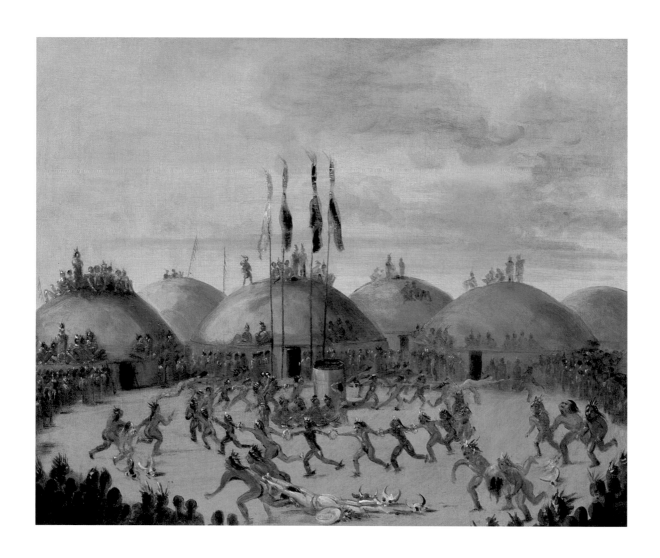

ASHER B. DURAND

(JEFFERSON VILLAGE (NOW MAPLEWOOD), NEW JERSEY 1796-MAPLEWOOD, NEW JERSEY 1886)

Apprenticed to an engraver early in his career, Asher Brown Durand became one of New York's leading engravers in the 1820s. During this same period, he also played an important role in the founding of the National Academy of Design in 1826. He served as its president from 1845 to 1861. Durand also helped establish the New-York Drawing Association (1825), the Sketch Club (circa 1827) and the Century (Century Association, 1847.) His election to James Fenimore Cooper's Bread and Cheese Club (The Lunch Club) in 1825 indicates the prominent position he held within the artistic and literary circles in New York City.

Durand was among the first artists to encourage his colleagues to paint truly American landscapes. In an article dated January 17, 1855 which appeared in *The Crayon*, a leading art periodical of the time, he wrote:

Go not abroad then in search of material for the exercise of your pencil, while the virgin charms of our native land have claims on your deepest affections...The `lone and tranquil' lakes embosomed in ancient forests, that abound in our wild districts, the unshorn mountains surrounding them...the ocean prairies of the West, and many other forms of Nature yet spared from the pollutions of civilization, afford a guarantee for a reputation of originality that you may elsewhere long seek and find not.

The founding of the Academy and his association with fellow artists encouraged Durand to pursue painting. A master of detail and observation, the artist studied from nature and not from the works of other artists. As a result, he produced inspired landscapes. The key to Durand's ideas, however, lies in his deeply religious concept of Nature as teacher of morality and truth. He felt that art must not merely be picturesque or technically exciting, but rather a vision of God through nature.

Indian Rescue (alternatively titled *Landscape, the Rescue*, 1846) combines all of the above elements in magnificent detail, which reflects Durand's training as an engraver. The painting evidences an awareness of the Romantic style so popular in Europe at the time.

5. *Indian Rescue* (1846), oil on canvas, 45 x 36"

HENRY INMAN

(UTICA, NEW YORK 1801-NEW YORK, NEW YORK 1846)

Inman was apprenticed to painter John Wesley Jarvis from 1814 to 1821. He began his professional career in New York City and spent the next decade working there as a portrait, genre and landscape painter. In 1831 he moved to Philadelphia where he met Thomas McKenney, newspaper editor and former chief of the Bureau of Indian Affairs in Washington, D. C. In the 1820s McKenney had commissioned Charles Bird King to paint portraits of important Indians who were visiting the nation's capitol on official tribal business. McKenney hired Inman to copy King's portraits, which were then reformatted into lithographs for use in a book McKenney had envisioned. He and James Hall later published these as *The Indian Tribes of North America with Biographical Sketches and Anecdotes of the Principal Chiefs* (three volumes, 1837-1841).

Except for minor alterations to the background, Inman's copies were true to the original portraits by King. In an exhibition of Inman's portraits in New York in 1836, the artist was acclaimed for the historical accuracy with which he depicted the features and costumes of his Indian subjects.

Inman's faithful attention to detail is evident in his portrayal of *Crouching Eagle* (1833-1837), whose Indian name was *Wakechai*. He was a popular and respected chief of the Sac tribe. Known for his honesty and friendly disposition, he dedicated his efforts to maintaining peace between his own nation and the United States Government. Crouching Eagle was a member of the delegation which accompanied General William Clark to Washington in 1824 on a treaty-signing mission.

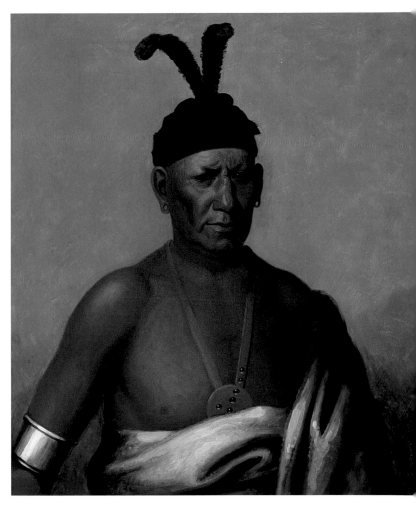

6. *Crouching Eagle* (1833-1837), oil on canvas, 30-1/4 x 25-1/4"

ALFRED JACOB MILLER

(BALTIMORE, MARYLAND 1810-BALTIMORE, MARYLAND 1874)

Miller studied portraiture for a year with Thomas Sully before embarking for Europe in 1833. He studied painting in Italy and at the Ecole des Beaux Arts in Paris. Upon his return home, Miller enjoyed success as a portrait painter.

By 1836, due to a plethora of portrait painters in Baltimore, the artist established his studio in New Orleans. There he was commissioned as staff artist by Scottish lord, Captain William Drummond Stewart, to record the high points of a hunting trip. This expedition led to the Rocky Mountain Fur Trappers Rendezvous of 1837, which as with many episodes in the American West, was one of its vital, yet short-lived historical chapters. Miller was among the first American artists to paint scenes of the Rocky Mountains, and the only artist to witness and record the mountain men and Indians in the heyday of the Rendezvous.

Following his western sojourn, Miller spent time first in his New Orleans studio then later in Baltimore where he finished works based on his sketches. Eighteen of these oils were exhibited in 1839 at the Apollo Gallery in New York before being shipped to Stewart in Scotland. Miller spent from 1840 to 1842 in Scotland where he decorated Stewart's castle on a grand scale with scenes from the 1837 hunting expedition.

The artist returned to Baltimore and spent the rest of his days painting portraits and Indian scenes from his 1837 sketches. Based on watercolor sketches entitled *The Bravado* and *Indians Tantalizing a Wounded Buffalo*, this painting, *The Buffalo Hunt* (circa 1850), depicts the dramatic moment when the wounded animal is isolated and about to meet its death. Miller wrote: "The chase of the Bison is attended with danger, for although in general shy, and flying from the face of man, yet when wounded they become furious, and make fight to the last."

Breaking Up Camp at Sunrise (circa 1845) documents life on the trail, and shows that the Indians and some of the rendezvous party traveled together for protection. Miller wrote that the Delaware Indians, pictured in the foreground, had a different sense of time and urgency than the rest of the party — they lagged behind and were always the last ones to join up with the caravan.

7. Breaking Up Camp at Sunrise (circa 1845), oil on canvas 30 x 44"

8. The Buffalo Hunt (circa 1850), oil on canvas, 30 x 50"

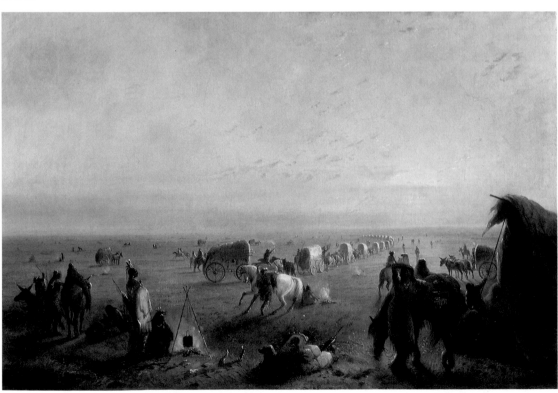

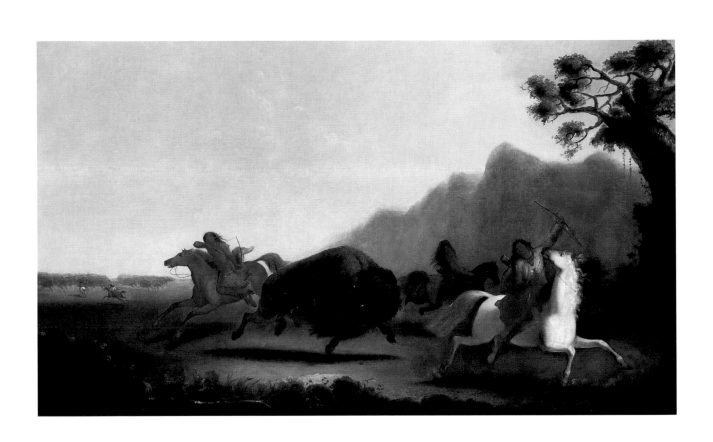

WILLIAM TYLEE RANNEY

(MIDDLETOWN, CONNECTICUT 1813-WEST HOBOKEN, NEW JERSEY 1857)

William Tylee Ranney began his career in business, but was soon thereafter apprenticed to a tinsmith. At this time he was exposed to the romantic stories of American folk heroes such as Daniel Boone and Francis Marion. He completed his apprenticeship by 1834, when he moved to Brooklyn to study drawing and painting.

Ranney's experience in the West was comprised of less than a year's duty in the Texas Army during the campaign against Mexico in 1836. This brief exposure produced a vivid impression on the artist and provided inspiration for studio paintings done in the East in the 1840s and 1850s.

Following his war experience Ranney returned to Brooklyn to resume his art studies. He settled in New York for a while. In 1850 he was elected an associate member of the National Academy of

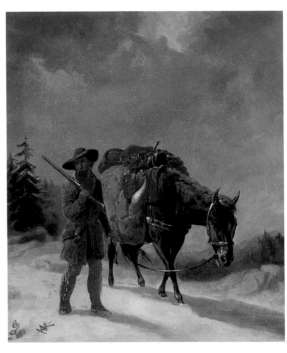

11. *A Trapper Crossing the Mountains* (circa 1853), oil on canvas, 30 x 25"

10. Boone's First View of Kentucky (1849), oil on canvas, 37-1/2 x 54-1/2"

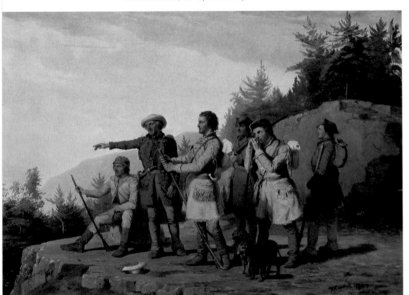

Design. In 1853 he made West Hoboken, New Jersey his permanent home.

Ranney's attitude towards the West was that of a genre artist and not a chronicler — he was one of the region's first painters to specialize in narrative. His purpose was not to capture the grandeur of Nature, but to weave a dramatic story about the

daily lives of white hunters, trappers and pioneers. *Boone's First View of Kentucky* (1849) grew out of a heightened interest in the West during the nineteenth century. Daniel Boone, whose exploits of heroic proportion were often mentioned in the popular journals of the day, was an appealing subject for artists. In this painting, Boone points to the "Promised Land," alluding to Manifest Destiny and westward expansion.

A Trapper Crossing the Mountains (circa 1853) is the only winter scene from Ranney's trapper series. The painting attests to Ranney's contact with the adventurous mountain men who served in the Texas Revolution of 1836. Their lives, dress and manners intrigued him and he painted them later in their characteristic surroundings in the mountains and on the plains.

JOHN MIX STANLEY

(CANANDAIGUA, NEW YORK 1814-DETROIT, MICHIGAN 1872)

Following a six-year apprenticeship to a wagonmaker, Stanley began work in 1834 as a sign and house painter in Detroit, Michigan. After traveling around the Northwest, he lived briefly in the East, making his living as a portrait painter.

In the ensuing years the artist accompanied several government surveys west. He joined the United States Corps of Engineers and accompanied Colonel Stephen Watt Kearney's expedition to California in 1846. He worked in California and Oregon from 1847 to 1848 and then in Hawaii in 1850. Stanley served as chief artist for the 1853 Pacific railroad survey led by Isaac Stevens.

While he was among the first American artists to paint vast panoramas, Stanley is renowned for his Indian portraits and scenes of Indian life. He was one of the first artists to use the daguerreotype for documentary purposes and he relied on these records for much of his later work. He spent time on his own in various western states taking portraits of prominent Indian chiefs and collecting Indian "curiosities." These were developed into 83 paintings and a number of artifacts which constituted the beginning of Stanley's Indian gallery. His Indian gallery ultimately consisted of 152 paintings of 43 different Indian tribes, of which 120 were portraits. He placed his collection with the Smithsonian Institution in 1852 hoping that the government would eventually purchase it. In 1865 the majority of his life's work was destroyed in two separate fires. Only five or six of his Indian gallery paintings survived the flames at the Smithsonian Institution in Washington, D. C., but everything perished at P. T. Barnum's American Museum in New York City.

From 1842 to 1853 Stanley lived and painted among the Indians. He chose to depict the quieter aspects of Indian life in the West. His style tends to be descriptive. *Friendly Indians Fleeing to Fort Benton* (1859) speaks of the role the military played in policing the American West. The army served to protect not only settlers from the Indians, but Indians from the settlers and from their Indian enemies.

12. ***Friendly Indians Fleeing to Fort Benton*** *(1859), oil on canvas, 26-1/4 x 38-1/4"*

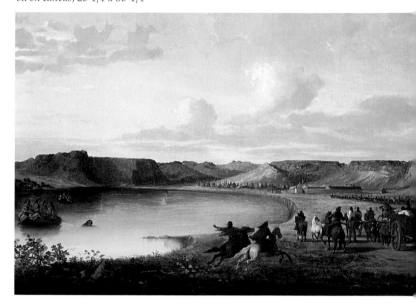

ALBERTUS DEL ORIENT BROWERE

(TARRYTOWN, NEW YORK 1814-CATSKILL, NEW YORK 1887)

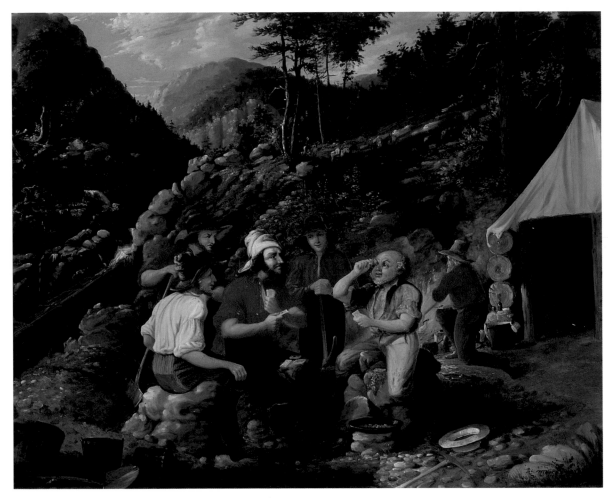

13. *Goldminers (1858), oil on canvas, 29 x 36"*

Having assisted his sculptor father as a young man, Browere decided to pursue a career in painting. He studied at the National Academy of Design in New York City and exhibited there from 1831 to 1846. In 1840 he moved to Catskill, New York, where he spent most of the rest of his life. While Browere was primarily a genre painter whose style has been called "anecdotal" or "Hogarthian," he was also known for his river landscapes. He often went painting with Thomas Cole, a leading artist of the Hudson River School.

Although most of Browere's painting was done in the Catskill Mountains, the quest for gold initially lured him to California in 1852. He prospected for the next three years and then returned to the East. Browere made a second western sojourn to San Francisco in 1858 and remained until 1862, when he returned to Catskill.

The large-scale visual drama of the western landscape was well suited to his style. He recorded California landscapes and its early settlements and mining operations. *Gold Miners* (1858) is a delightful anecdotal portrayal of everyday life in a California mining camp in the mid-nineteenth century. Unlucky in the gold fields, Browere nonetheless produced some of his best work while in the West.

JAMES WALKER

(NORTH HAMPTONSHIRE, ENGLAND 1818-WATSONVILLE, CALIFORNIA 1889)

English-born Walker grew up in New York City, where he began his study of painting at a young age. In the early 1840s he went to Tampico, Mexico, where he headed the Art Department at the Mexican Military College. He was living in Mexico City at the outbreak of the Mexican War in 1846. After Mexican friends aided his escape from the capital, he served as an interpreter for the American general, Winfield Scott. He saw and sketched many battles as well as the capture of Mexico City. The United States government commissioned murals and panoramas from him which were based on these sketches. The most widely acclaimed of these was the *Battle of Chapultepec* (1862).

After the war Walker visited California for a brief time before moving east. The artist had resumed his art career in New York City when he was called to serve as staff artist for the Union Army during the Civil War. He added to his fame with his two Civil War canvases, *The Battle of Lookout Mountain* and *The Third Day of Gettysburg*. Walker maintained a studio in San Francisco in the 1870s until he moved to Europe in 1878. In 1880 he returned to the United States to live in Washington, D. C. He left that city for California in 1884 where he lived until his death five years later.

It was during his frequent visits to the ranches owned by his Spanish-speaking friends in California that Walker witnessed the action and drama portrayed in such genre scenes as *California Vaqueros* (1876-1877). Walker's attention to detail adds to the historical importance of his work. The *vaqueros* were the predecessors of the modern-day cowboy in the United States. Much of their dress and language, like the words *lariat*, *remuda* and *rodeo*, was adopted from the Spanish.

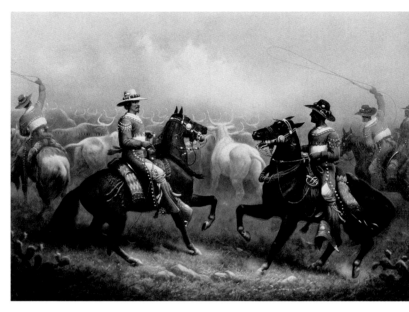

14. *California Vaqueros* (1876-1877), oil on canvas, 31 x 46"

CHARLES CHRISTIAN NAHL

(CASSELL, GERMANY 1818-SAN FRANCISCO, CALIFORNIA 1878)

After studying art in Cassell, Nahl left Germany in 1846 to study under Horace Vernet in Paris. He exhibited in the Paris Salon in 1847 and 1848. After the fall of King Louis Philippe, Nahl immigrated to New York where he made his living by painting and also exhibited at the American Art Union. In 1850 the artist caught the California gold fever and sailed to San Francisco via the Isthmus of Panama to try his hand at mining. He participated in mining camp life, working in the Rough and Ready Camp located northeast of Sacramento, California. During this time Nahl sketched the daily activities of his fellow miners. In 1851 he visited and sketched mining life at Sutter's Mill, another camp located at Coloma, California. That same year he moved to Sacramento where tragedy struck. All of his mining camp sketches were destroyed in the Great Sacramento Fire. Nahl had an excellent visual memory, however, and was able to reconstruct them.

In 1852 he decided on an art career and moved to San Francisco. There he operated an art and photo studio/gallery. He executed numerous drawings and engravings or lithographic reproductions based on his experience in the mining camps. Nahl's work also appeared in books, magazines and newspapers with illustrations of mining scenes and the lives of the early settlers. On account of his passion for accuracy, technical skill and firsthand knowledge of mining camp life, he became the leading interpreter of the California gold rush.

Nahl is considered one of California's premier genre painters. He depicted another aspect of the state's early history, namely the life on the vast *ranchos* (ranches) where *vaqueros* (cowboys) handled herds of longhorn cattle. *Vaqueros Roping a Steer* (1866) bursts with action as the two cowboys close in on the plunging longhorn.

*15. **Vaqueros Roping a Steer** (1866), oil on canvas, 42 x 51"*

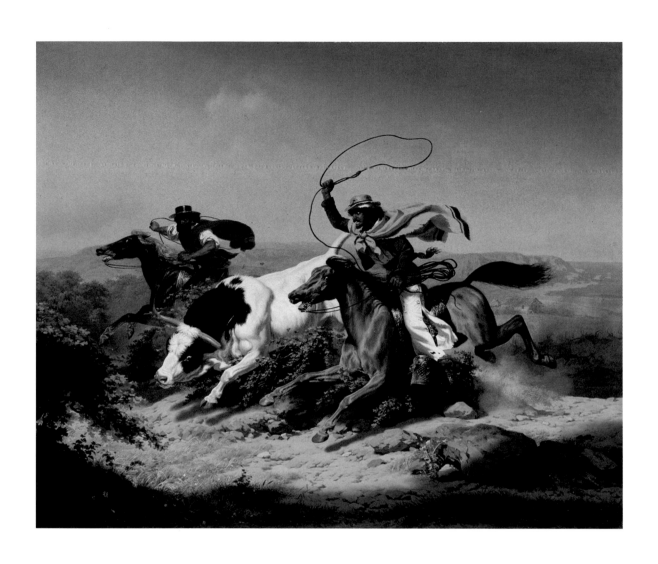

ARTHUR FITZWILLIAM TAIT

(LIVESEY HALL, NEAR LIVERPOOL, ENGLAND 1819-YONKERS, NEW YORK 1905)

Tait was already well launched in his career as an artist in the 1840s when he saw George Catlin's Indian Gallery on exhibition in Liverpool. The exposure to Catlin's work proved decisive, and he desired to see America for himself.

In 1850, Tait immigrated to the United States and settled in New York. There he became friends and collaborated with Louis Maurer, William Sonntag, and other American artists. While he is not known to have traveled any further west than Chicago, Tait nonetheless attempted to lend accuracy to his painting and depict frontier life accurately. To do this, he used as references literary sources and folios and books by Catlin and Karl Bodmer as well as Western artifacts borrowed from artist William Tylee Ranney. The popularity of Tait's animal, sporting, and western subjects made him one of the most successful artists of his day.

Currier and Ives, one of the most prolific lithography firms in nineteenth-century America, produced nearly all of his published graphics. The firm demanded and got the highest price for his lithographs — five dollars. In the 1860s, Currier and Ives produced large folio prints of Tait's western genre work in a series entitled "American Frontier Life." They published *On the War-Path* (1863), a lithograph which derived from Tait's first western painting, *On the Warpath* (1851). Between 1851 and 1862 he produced 22 paintings depicting the life of the trapper. In these paintings the lush forests suggest the Adirondacks, rather than the prairies of the trans-Mississippi West. As in his other trapper series paintings, the Indian, if depicted at all, is a small figure in the background.

*16. **On the Warpath** (1851), oil on canvas, 33 x 44"*

THOMAS WORTHINGTON WHITTREDGE

(SPRINGFIELD, OHIO 1820-SUMMIT, NEW JERSEY 1910)

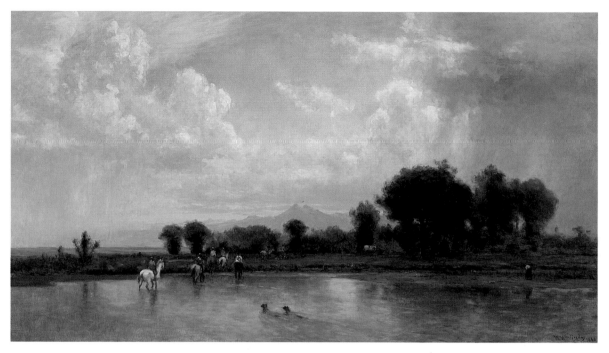

17. **On the Plains, Cache La Poudre River** (1865), oil on canvas, 23-1/2 x 24-1/2"

By the time he arrived in the West, Worthington Whittredge had spent ten years painting in Europe as part of the Grand Tour that American artists felt obligated to make at that time. John F. Kensett, Sanford Gifford and Albert Bierstadt numbered among his painting companions. After his return to New York in 1859 he was elected a member of the National Academy of Design.

Whittredge was among the first figures of the second generation Hudson River School painters to find his way west. In 1865, he joined General John Pope's survey of the Missouri Territory from Fort Leavenworth, Kansas, through present-day Colorado and into Santa Fe, New Mexico. The expedition returned via the Santa Fe Trail. Whittredge made two more trips west in 1870 and in 1871. On his second journey, he was accompanied by his former painting companions, Kensett and Gifford. He sketched the areas around Denver and Greeley, Colorado. Whittredge used the field sketches from these trips to compose studio landscapes of the West. His western experience transformed his work, helping him develop a new depth of vision and a mastery of vast spaces and natural light. He wrote of his experience:

I have never seen the plains or anything like them. They impressed me deeply. I cared more for them than for the mountains, and very few of my western pictures have been produced from sketches made in the mountains, but rather from those made on the plains with the mountains in the distance. Whoever crossed the plains at that period, notwithstanding its herds of buffalo and flocks of antelope, its wild horses, deer and fleet rabbits, could hardly fail to be impressed with its vastness and silence and the appearance everywhere of an innocent, primitive existence.

On the Plains, Cache La Poudre River (1865) stemmed from Whittredge's first visit to the West and is one of less than five finished oils that survived from the Pope expedition. The painting is one of his earliest large-scale canvases of the American West. Whittredge developed a great love for this landscape which had an almost religious effect on him. The soft, atmospheric effects add to the tranquility of the scene and emphasize the feeling of harmony between the Indian and nature.

HEINRICH EDOUARD MÜLLER

(POLTAVA (RUSSIA) 1823-DRESDEN, GERMANY 1853)

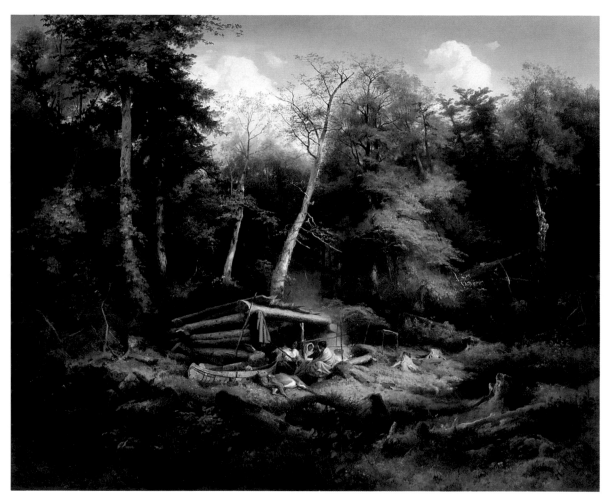

18. **Indian Camp in the Forest** (1853), oil on canvas, 33 x 41"

Not much is known about Müller. Thieme-Becker lists him as a landscape painter who studied with A. L. Richters. Müller also spent time in the United States. The Picture Gallery in Dresden, Germany has a painting by him entitled *Am Michigansee in Nord Amerika (On Lake Michigan in North America*, 1853) which suggests that he and Henry Müller, listed in the *New York Historical Society's Dictionary of Artists in America*, are one and the same person. The following information supports this thesis: Henry Müller painted in North America between 1848 and 1853. He exhibited at the National Academy of Design between 1850 and 1852, and at the American Art Union in 1852. From 1851 to 1852 his address was listed as New York City. The subjects of his paintings exhibited in New York denote training in Europe as well as visits to New York state's Niagara and Trenton Falls.

Indian Camp in the Forest (1853) shows the house forms of the Native Americans who lived in the Northeast. The foliage and landscape are also typical of the area. This upholds the notion that Müller painted this canvas either around Lake Michigan or in New York state. The painting was reproduced in Friedrich von Boetticher's *Malerwerke des 19 Jahrhunderts (Paintings of the Nineteenth Century*, 1853) as *Urwald mit Blockhaus (Virgin Forest with Log Cabin)*.

GEORGE INNESS

(NEWBURGH, NEW YORK 1825-BRIDGE OF ALLAN, SCOTLAND 1894)

Originally apprenticed to a map engraver in New York, Inness began his painting career in 1842. His early works were lyrical scenes in the tradition of the Hudson River School. The artist spent many years studying in Europe, notably in Rome, Paris and Normandy. He was influenced by the Barbizon School and modeled his work after Corot, whom he admired. Inness became famous for his landscapes, both in Europe and in the United States. Recognition of his work came in 1868 when the National Academy of Design elected him to membership.

From 1884 to 1888 Inness traveled in the southern United States, Mexico and Cuba. He was the guest of artist William Keith in San Francisco in 1891. During that time he accompanied Keith on sketching trips to the Monterey Peninsula and to the Yosemite Valley, and exhibited with the San Francisco Art Association. In 1894 Inness traveled to Europe, where he visited Paris, Baden and Munich, and then journeyed on to Scotland where he died.

Painted in a romantic, but still representational style, *Afterglow on the Prairie* (1856), shows two hunters crouched in the tall grasses in the foreground. The sun is just setting, bathing the prairie in an amber glow and creating an interesting interplay of shadow and light.

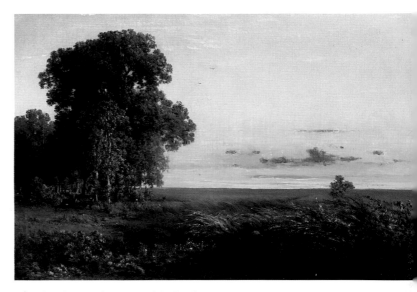

19. ***Afterglow on the Prairie*** (1856), *oil on canvas, 13-7/8 x 21"*

CARL WILLIAM HAHN

(EBERSBACH, SAXONY, GERMANY 1829-DRESDEN, GERMANY 1887)

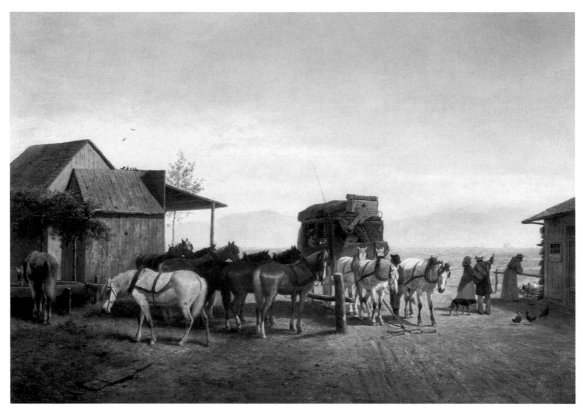

20. *California Stage Coach Halt, 1875*, *oil on canvas, 28 x 40"*

Hahn was studying at the Düsseldorf Academy when he met and came under the influence of Emanuel Leutze. The latter did not teach at the Academy, but had founded the "Malkasten," an independent artists club where academy teachers and painters mingled freely with independent artists Leutze, most famous for his painting, *Washington Crossing the Delaware*, considered himself an American and did everything possible to encourage American painters to study in Düsseldorf. Hahn consequently met American artists such as Charles Wimar, Worthington Whittredge and George Caleb Bingham.

By the time he came to the United States, Hahn had already developed his genre style and was a professional artist of some stature. He had won gold and silver medals from the Dresden Gallery, and placed watercolors in the National Gallery in Düsseldorf. He had met William Keith in 1869 in Düsseldorf and in 1871 the two men shared studio space in Boston. A year later, Hahn accompanied Keith to San Francisco where they rented a studio in The Mercantile Library

Building. By 1876 he was well integrated into San Francisco's artistic circle: he became president of the Bohemian Club and the director of the San Francisco Art Association. From 1872 to 1882 Hahn resided in California, making sketching trips to Yosemite, the Sequoia Groves, the Sierra Nevada Mountains and the Napa Valley.

California Stage Coach Halt, 1875 depicts a way station at the point on the long stagecoach journey where the spent horses were exchanged for fresh ones and the travelers, weary of sitting, were able to stretch their legs. Hahn uses the naturalistic color tones characteristic of the Düsseldorf School.

THOMAS HILL

(BIRMINGHAM, ENGLAND 1829-RAYMOND, CALIFORNIA 1903)

Thomas Hill immigrated to the United States in 1844 and began his art career in 1853 by taking classes at the Pennsylvania Academy of Fine Arts in Philadelphia. After his study there he worked in the Boston area where he painted with a group of artists that included Durand, Inness, Bierstadt and Virgil Williams.

For reasons of health, Hill moved to California in 1861 and settled in San Francisco. In 1862 he made his first painting trip to Yosemite with artists Virgil Williams and William Keith. Yosemite became such a source of inspiration for Hill that he returned there to sketch and paint over the next 30 years. Hill studied in Paris for a few months in 1866 and then worked in Boston. In 1871 he returned to San Francisco, where he resided during the winter, spending the summer months in Yosemite.

While Hill painted in other parts of the West, such as the Rocky Mountains and Yellowstone National Park, his paintings of California's Yosemite Valley are classics. They earned him the title "Pioneer Artist of Yosemite." Hill's *View of Yosemite Valley* (1871), imparts the area's grandeur and is a fine example of a scene he depicted numerous times. His palette of light pastel colors denotes the influence of the French Impressionists.

21. *A View of Yosemite Valley* (1871), oil on canvas, 30 x 48"

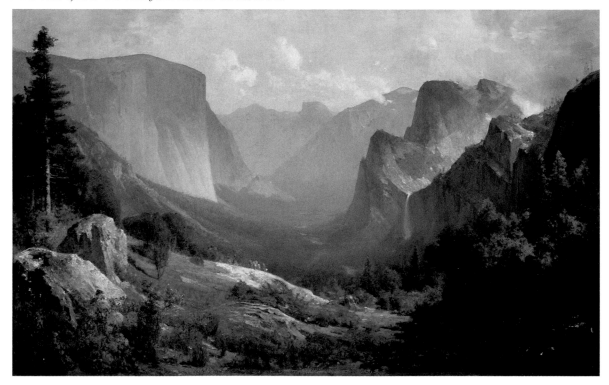

ALBERT BIERSTADT

(SOLINGEN, GERMANY 1830-NEW YORK, NEW YORK 1902)

Bierstadt's parents brought him to the United States from Germany when he was one year old. In his early twenties, Bierstadt went to study in Düsseldorf. He and Worthington Whittredge painted together there and in the area of Lake Lucerne. In 1856 he, Whittredge and Sanford Gifford were painting companions in Rome. Bierstadt later returned to New Bedford, Massachusetts, where he taught painting and executed large European landscapes.

Early in 1859, he joined General Frederick Lander's expedition to survey a wagon route to the Pacific Ocean. By May of that year, Bierstadt was on the same route that Alfred Jacob Miller had traversed twenty-two years earlier. In the interim, this had become the much-traveled Oregon Trail. Bierstadt both sketched and took stereopticon views of the scenery and the Indians he encountered. In 1863 he made a second trip west to the Rocky Mountains in Colorado and then on to the Pacific Coast. On his third western sojourn in 1872-1873, he accompanied famed geologist, Clarence King, to the headwaters of King's River, California.

When he returned to New York, the artist developed his small field sketches into the monumental oil paintings he felt were needed to interpret the true proportion of the great outdoors.

His use of theatrical light, turbulent skies and monumental granite cliffs were meant to impress the viewer with the grandeur of the Western wilderness. His work became extremely popular with the general public as well as with wealthy collectors. In fact, Bierstadt's paintings brought record prices. In 1865, for example, *The Rocky Mountains* fetched $25,000.

Bierstadt's popularity declined in the 1880s. By then, his style and colors were considered outdated, particularly when compared to the new Impressionist painters in France. The large, dramatic landscape, *The Last of the Buffalo* was refused for the 1889 Paris Exposition. At the time of his death in 1902, Bierstadt had lapsed into obscurity. His subsequent return to popularity demonstrates the vagaries of taste in art.

Wind River, Wyoming (1870), a painting derived from sketches Bierstadt made on the 1859 Lander expedition, depicts the Wind River Range of the Rocky Mountains. The artist's western sojourn affected him deeply. In an article for *The New Bedford Daily Mercury* dated September 14, 1859, he wrote: "...such beautiful cloud formations, such fine effects of light and shade, and play of cloud shadows across the hills, such golden sunsets, I have never before seen. Our own country has the best material for the artist in the world."

22. **Wind River, Wyoming** (1870), oil on canvas, 54 x 85"

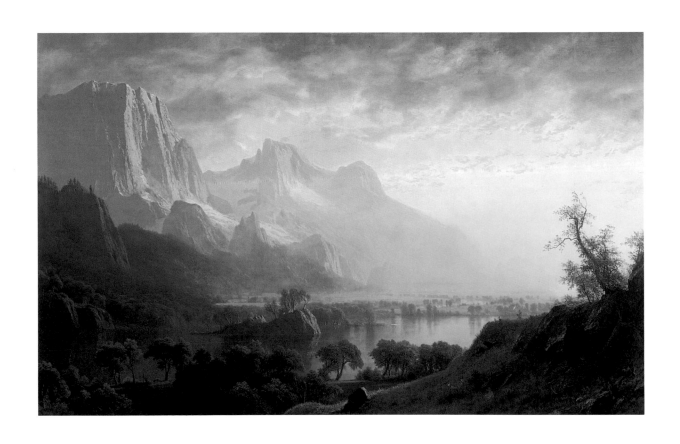

WILLIAM JACOB HAYS

(NEW YORK, NEW YORK 1830-NEW YORK, NEW YORK 1865)

Hays was born in New York City where he spent most of his artistic career. He studied painting there with John Rubens Smith and began exhibiting his work in 1852.

Known chiefly as an animal painter, Hays established his reputation with works resulting from his only western journey. In 1860 the artist followed the route up the Missouri River — the same one that Catlin had travelled nearly 30 years previously— aboard the steamboat *Spread Eagle*. During the 1,800-mile trip from St. Louis to Fort Union, the artist sketched trading posts visited along the way as well as scenes of Indian and animal life.

Upon his return to New York, Hays produced many large canvases from his sketches, depicting vast buffalo herds and an abundance of other Great Plains fauna. He won critical acclaim for these canvases, both at home and abroad. Art critic, Henry T. Tuckerman, wrote about one of these paintings, entitled *The Herd on the Move* (now in the collection of the Thomas Gilcrease Institute of American History and Art, Tulsa, Oklahoma), in his *Book of the Artists* (1867):

By the casual observer, this picture would, with hardly a second thought, be deemed an exaggeration; but those who have visited our prairies of the far West can vouch for its truthfulness...As far as the eye can reach, wild herds are discernible; and yet, farther behind these bluffs, over which they pour, the throng begins, covering sometimes a distance of a hundred miles. The bison collect in these immense herds during the autumn and winter, migrating south in winter and north in summer, and so vast is their number that travellers on the plains are sometimes a week in passing through a herd.

In addition to his western sojourn, Hays also travelled to the Adirondacks and Nova Scotia to observe animals in their native inhabitant. He created paintings of caribou, moose and deer resulting from these trips.

In a letter to his mother from his 1860 western tour, Hays wrote: "On my way down the river I saw thousands of buffalo they covered the bluff and prairie as far as we could see." As in his other large buffalo canvases, *The Gathering of the Herds* (1866), celebrates the animal which even in the artist's time was considered an endangered species. The skull in the foreground portends doom for the free-roaming bison of the Great Plains.

23. *The Gathering of the Herds* (1866), *oil on canvas, 42 x 75"*

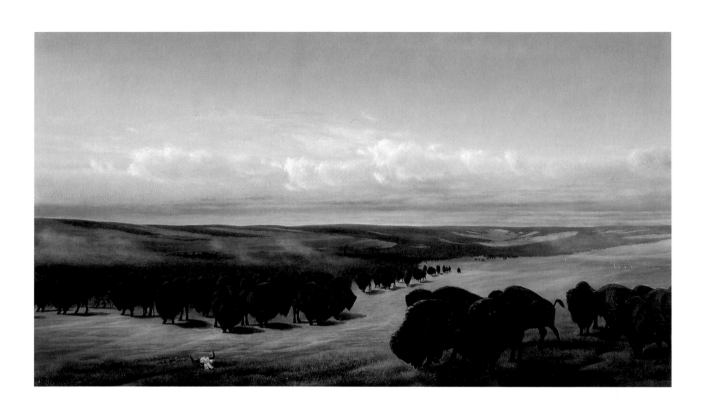

HERMAN HERZOG

(BREMEN, GERMANY 1831-PHILADELPHIA, PENNSYLVANIA 1932)

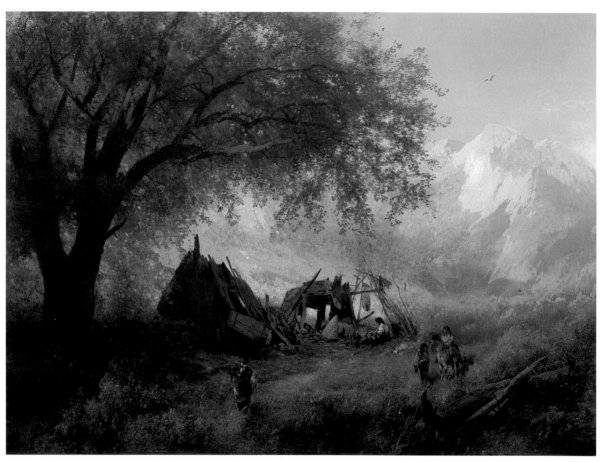

24. *Indian Hogans in the California Sierras* (*circa 1875*), *oil on canvas, 36-1/4 x 48-1/4"*

Herzog realized his calling as an artist while still a child. By age fifteen, he was contributing to his family's livelihood through his earnings as a painter. In 1848 he entered the Düsseldorf Academy where he studied with Johann Wilhelm Schirmer. Some years later, the young artist blossomed under the private tutelage of Hans Gude, the celebrated Norwegian landscape painter. At Gude's urging, Herzog went to Norway to paint. This trip was instrumental in forming his style.

By the time Herzog first visited the United States in 1861, he was a celebrated landscape artist in Europe. His paintings were acquired by such royal personages as The Queen of Hanover, Queen Victoria and Czar Alexander. Herzog eventually settled in Philadelphia, but traveled widely to paint. In 1874 his desire to see the great natural wonders of the Far West led him to Salt Lake City and the

Coronado Islands in Mexico. A year later he painted in the Yosemite Valley and Colorado.

Indian Hogans in the California Sierras (circa 1875) attests both to his Düsseldorf training and to his interest in putting the landscape into perspective by interjecting human figures.

Herzog's technique is as polished and competent as Bierstadt's, but his paintings are more forthright in their representation of nature.

LOUIS MAURER

(BIEBRICH-ON-THE-RHINE, GERMANY 1832-NEW YORK, NEW YORK 1932)

Maurer studied mathematical drawing and animal anatomy as a young man. When his family immigrated to the United States in 1841, he took a job as staff artist for Currier and Ives. The company hired Maurer because of his skills as a draftsman. In his capacity as lithographic artist, he was responsible for drawing copies of his own and other artist's works which were then printed. For example, he copied onto stone paintings by Arthur Fitzwilliam Tait entitled *The Pursuit* and *Scenes from the Rocky Mountains*. Between 1853 and 1893 Maurer produced over a hundred works for Currier and Ives. Until 1860 his assignments were to produce lithographs on any subject that was marketable. Like Tait, when Maurer was assigned Indian subjects, he went to the Astor library and studied the lithographs of George Catlin and Karl Bodmer because of their accuracy.

Maurer's involvement in the portrayal of western subject matter piqued his interest in the region and ultimately resulted in two trips to the West. The first trip — an extensive one — was made as a guest of Buffalo Bill. *Buffalo Bill Fighting Indians* (circa 1885), one of the paintings resulting from his first visit, shows a lithographer's attention to detail as well as a sense of dramatic color.

Recognition as a painter came to Maurer late in life. His first one-man show in New York City was held in 1931, the year preceding his death.

25. **Buffalo Bill Fighting Indians** (circa 1885), oil on canvas, 26-3/4 x 36"

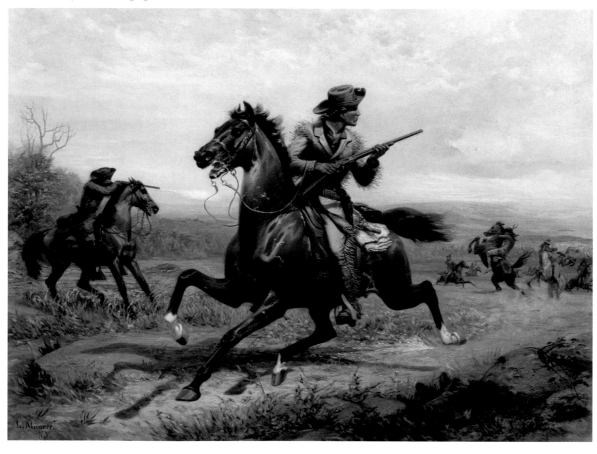

THOMAS MORAN

(BOLTON, LANCASHIRE, ENGLAND 1837-SANTA BARBARA, CALIFORNIA 1927)

Moran's family immigrated to the United States when he was seven years old. Some time later he was apprenticed to a firm of wood engravers in Philadelphia where he mastered the skill of sketching designs onto woodblocks. He also began to make small watercolors on his own. His brother, Edward, was a competent marine painter and Thomas' work benefitted from their close association.

In 1861 Moran returned to England to study and copy the work of J. M. W. Turner, finding inspiration in that artist's dramatic handling of color. Moran

26. *Indian Pueblo, Laguna, New Mexico (1908),*
oil on canvas, 20-1/2 x 30-1/4"

later produced paintings which utilize the same sublime coloristic effects on the American landscape that Turner employed in his paintings of English landscape and marine paintings. In 1866, Moran made a second sojourn to France where he met and was influenced by Corot. He also participated in the Exposition Universelle of Paris in 1867.

Moran first journeyed west in 1871 with Dr. Ferdinand V. Hayden's survey party to explore the Yellowstone region. Moran was the first artist to record the area. He assisted pioneer Rocky Mountain photographer, William Henry Jackson, with the expedition's pictorial recording. His watercolors of Yellowstone's geysers, hot springs, and lakes showed

him to be the unsurpassed master of this medium. Combined with Jackson's photographs, Moran's watercolors were instrumental in convincing the United States Congress to designate Yellowstone as the world's first national park.

In 1873 the artist accompanied another government expedition, led by Major John Wesley Powell, to the Grand Canyon. The following year he again joined Hayden on his survey of Colorado. Moran made several additional trips to the West, some with his artist brother Peter. Upon his return to the studio, Thomas translated his field sketches into enormous landscapes. His popularity never declined and he remained an active painter well into his eighties, living long enough to see many of his favorite sketching areas preserved in the National Park system.

Moran made several trips to New Mexico, an area he found "flooded with color and picturesqueness." *Indian Pueblo, Laguna, New Mexico* (1908) was one of the artist's attempts to call attention to the Southwest's enchanting landscape.

One of two landscapes Moran exhibited at the Paris Exposition Universelle in 1867, *Children of the Mountain* (1866) was displayed along with landscapes by other important American artists like Bierstadt, Durand, Inness, Whittredge and Frederic Church. *Children of the Mountain* is one of Moran's key works, for two reasons. It grew out of his quest in the early 1860s for landscapes that were wilder, more distant and exotic, which he ultimately found in the American West. He left this painting with Roswell Smith, the publisher of *Scribner's* magazine, as collateral to finance his 1871 trip to Yellowstone with the Hayden survey.

27. *Children of the Mountain* (1866), oil on canvas,
62-1/8 x 52-1/8"

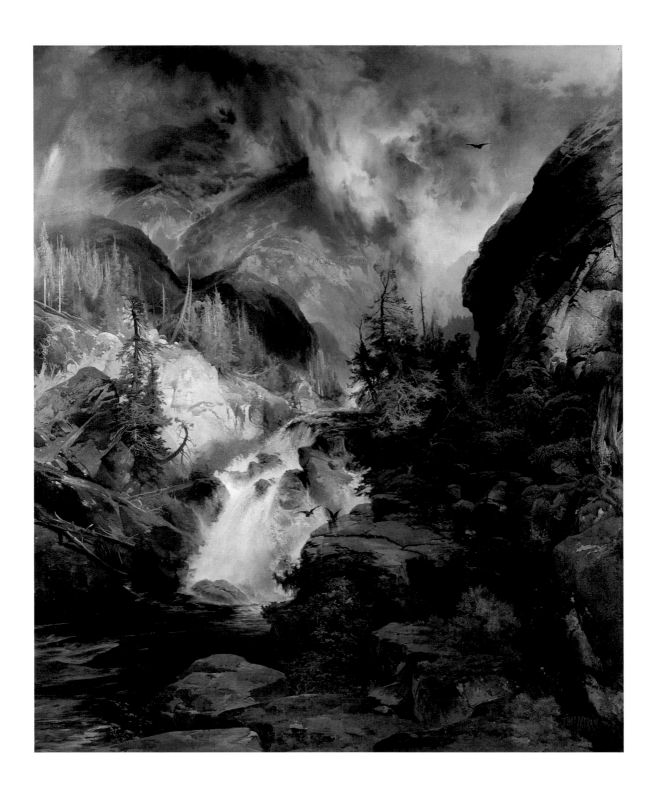

JULES TAVERNIER

(PARIS, FRANCE 1844-HONOLULU, HAWAII 1889)

Tavernier received his art training in Paris from 1861 to 1865. He exhibited landscapes and genre paintings regularly at the Paris Salon from 1865 to 1870. For political reasons, he fled France during the Franco-Prussian War, arriving in New York in 1871, where he worked as an illustrator for the city's flourishing magazines. As a result of a subscription war with *Leslie's* in 1873, *Harper's Weekly* commissioned Tavernier and fellow Frenchman, Paul Frenzeny, to record their journey along the route of the transcontinental railroad. This trip took the two artists through Missouri, Kansas, Texas and into Indian territory (Colorado, Wyoming, and Nebraska).

The pair wintered in Denver and then went on to San Francisco. Both men were accepted into its art circle, and Tavernier was elected a member of the Bohemian Club in 1874. He remained a lifetime member, and associated with fellow club members Julian Rix, Joe Strong and Amadée Joullin. Tavernier later established a studio on the Monterey peninsula where he painted, exhibited his work and gave art lessons. He is credited with the founding of the Monterey Art Colony.

Much of his work in the five years after his arrival in California was based on his experiences and interest in the history of the West. His paintings commanded good prices and his work was often reproduced in the San Francisco press. Later, on personal debt resulting from his aversion to toil and his penchant for the "good life" drove Tavernier from the mainland to Hawaii. There his financial condition worsened, and he was forced to paint "potboilers" to survive. Already fond of alcohol, he began seriously drinking, and soon thereafter died of alcoholism. His friends from the Bohemian Club in San Francisco erected a monument over his grave.

Indian Village of Acoma (1879), based on the legend of the return of Montezuma, shows Tavernier's talents as a colorist, his control of large masses and his mastery of space and light.

*28. **Indian Village of Acoma** (1879), oil on canvas 64 x 29-1/2"*

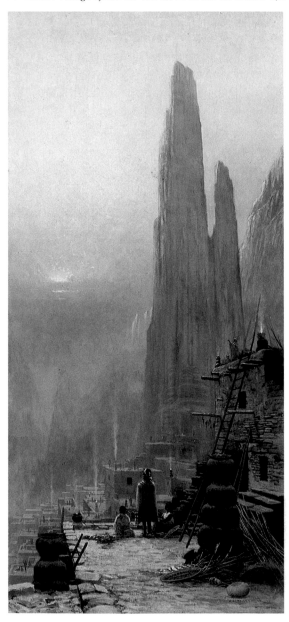

HENRY FARNY

(RIBEAUVILLE, ALSACE, FRANCE 1847-CINCINNATI, OHIO 1916)

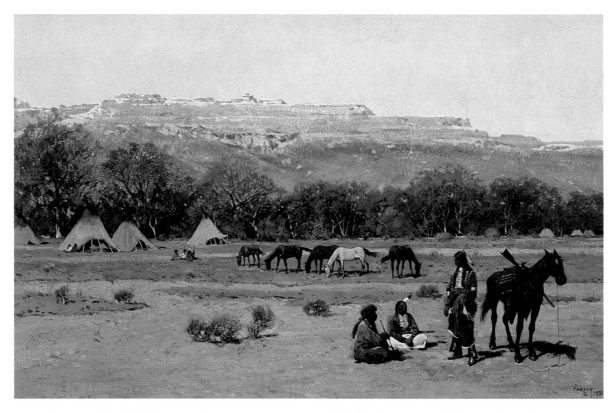

29. *Indian Encampment* (1901), gouache, 9-1/2 x 14"

The Farny family fled France for the United States when Henry was a child. He grew up in Cincinnati when that city was an important cultural center. In 1867 he traveled to Europe and spent three years studying art in Düsseldorf, Vienna and Italy. When he returned home, he supported himself for many years by illustrating books and by selling illustrations to *Harper's*, *Century* and other national magazines.

From the time of his first trip to the West in 1881 until the end of his career, Farny continued to successfully market his Indian paintings. After collecting a large cache of Indian artifacts and taking over one hundred photographs, Farny returned to his Cincinnati studio to paint. He used the photographs as an aid for detail and for general background in his paintings. Between 1889 and 1893, Farny established a great number of motifs which he later expanded upon and embellished: the hunting party, the single hunter, pueblo scenes, and Indian camp scenes like *Indian Encampment* (1901), a precisely rendered gouache.

During his lifetime, Farny's reputation was considerable. Even though he is known primarily as a painter of Indians, his depiction of the light and mood of the western landscape also represents his contribution to American art.

RALPH ALBERT BLAKELOCK

(NEW YORK, NEW YORK 1849-ADIRONDACKS, NEW YORK 1919)

Blakelock's father, a physician of comfortable means, sent his son to the Free Academy of the City of New York in 1864. He studied art and music there for two years. The young artist then left college and devoted himself to landscape painting. In the late 1860s Blakelock sketched and painted in the Catskills. In 1867 he began to exhibit at the National Academy of Design.

Financed by his father, Blakelock made his first trip to the West in 1869. He journeyed by rail and by stagecoach to the states and territories of Nebraska, Kansas, Colorado, Wyoming, Utah, Nevada and California. Along the way he noted and sketched the topography, settlements and forts, and Indian tribes he encountered. Blakelock spent time and made friends with the Native Americans and returned to New York with vivid memories of his experiences among these people as well as with their gifts of necklaces, sashes and blankets. The artist visited the West a second and last time in 1872, again with his father's financial support, and then returned to New York to live. He later made painting excursions to the New England states, the Adirondacks and other environs closer to home.

Blakelock's painting style grew out of the Hudson River School tradition. He continued to develop his own unique style which has become known as contemplative or visionary. Unfortunately his paintings were not in accord with public taste, and he had difficulty selling his work. The rejection of his work and his subsequent financial straits, coupled with the strain of supporting nine children, finally broke the artist's mental health. Blakelock spent his last years in an asylum. Ironically, the public began to appreciate his work when he was no longer able to do any serious painting.

The West, in particular its tribes of Native Americans, had a profound effect on Blakelock's artistic career. He considered the Indian America's ancient and natural inhabitant. As depicted in *Western Landscape* (alternately titled *New Mexico Landscape*, 1869), painted after his first trip to the region, the artist uses Indian encampments or single tepees as the focal point in the landscape. While this subject is characteristic of a large body of Blakelock's work, here the colors are brighter and more impressionistic than his later visionary paintings.

*30. **Western Landscape,** (1869), oil on canvas, 12 x 20"*

VALENTINE WALTER BROMLEY

(LONDON, ENGLAND 1848-LONDON, ENGLAND 1877)

Bromley began his art career studying engraving with his father, who was a member of the Society of British Artists. Because he was an efficient draftsman, Valentine had no difficulty obtaining commissions from British journals and publications. *Fun*, *Punch* and the *Illustrated London News* frequently used Bromley's illustrations.

In 1874 the Earl of Dunraven became Bromley's patron and retained the artist to portray his hunting adventures on his third trip to the American West. Dunraven had just purchased a 4,000-acre tract of land in Estes Park, Colorado, and was also collecting information and anecdotes for a book he planned to publish. Bromley witnessed and recorded Indian tribal dances, ritual trading and domestic life in the Crow camp near Fort Ellis, Montana. Some of his drawings of burials, games, women's tasks and Indian courtship appeared in the *Illustrated London News* from 1875 to 1877. His Indian paintings were on exhibit in London at the time of his death from smallpox at age 29.

Paying close attention to detail in *Portrait of an Indian Chief* (1875) — the face paint, the bird and the arrangement of the feathers in the headdress — Bromley presents his own vision of this personality.

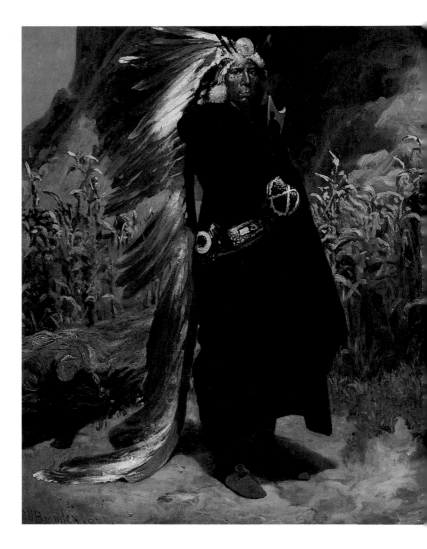

31. ***Portrait of an Indian Chief*** (1875), oil on canvas, 23 x 18-1/2"

ALEXANDER POPE

(DORCHESTER, MASSACHUSETTS 1849-HINGHAM, MASSACHUSETTS 1924)

*32. **After the Hunt** (1900), oil on canvas, 52 x 48"*

Pope demonstrated an interest in drawing as a child. Although he said that he was self-taught, the artist studied anatomy and perspective for a short time with William Rimmer. He made his first artistic attempts in the 1870s when he ran a lumber business with his father. During this time he carved wooden game birds which he painted to imitate real-life fowl. Following the death of his father, Pope is listed as an artist in the 1880 Boston directory.

Primarily a painter of animals, Pope was a hearty, sports-loving man, in the same late nineteenth century tradition as artist Frederic Remington. He was considered a "gentleman-artist" and is best known for his portraits of hunting dogs, race horses and champion cattle as well as for his renderings of game birds. However, between 1879 and 1883 Pope produced sculptures of lions and of Boston clergymen, and in his later years, he derived his livelihood from portrait painting.

Besides his animal paintings, portraits and sculpture, Pope also painted still-life *trompe l'oeil* (illusionary) pictures. He was one of a large group of painters (among them William M. Harnett and John Peto) of still-life deception pieces active in the late nineteenth century. In an 1891 review of Pope's painting, one critic wrote: "They are certainly marvelous in the illusions they produce...One of Pope's favorite pastimes is to paint firearms, birds, rabbits and the like hanging to a slate colored door...semblances of reality that deceive the sense of sight... skillful manipulations of shadows and by a faithfulness in the matter of texture that comes from careful study." *Trophy of the Hunt* (1900) is one of the artist's few trophy-series illusionistic works. The calling card with his signature and the hunting knife are treated as if they were real objects stuck into the painting's frame.

CHESTER LOOMIS

(SYRACUSE, NEW YORK 1852-ENGLEWOOD, NEW JERSEY 1924)

Loomis studied under portraitist Harry Ives Thompson before setting off for two years of study in Paris under Leon Bonnat. Loomis lived in France from 1874 to 1885 during which time he exhibited in six Paris salons, as well as at the Royal Academy and the Institute of Oil Painters in London.

Shortly after his return to the United States, he was elected to the Society of American Artists in 1888. He became an associate member of the National Academy of Design in 1906. Loomis settled in Englewood, New Jersey in 1890 and made his living primarily from portrait painting there and in New York City. Although the artist also did easel painting, illustrations and designed stained-glass windows, he is best known for his murals. A mural depicting Henry Hudson discovering the Hudson River is still in existence at the Public Library in Englewood.

In 1886 Loomis went west to Texas and bought a ranch near San Angelo with his brother. His family spent many summers there, as well as the entire year of 1898. *Antelope Hunters, Texas, 1887* depicts a scene on the ranch in which the artist painted himself standing by his horse while his brother skins an antelope. The picture evidences Loomis' excellent academic training and the effect of the *plein air* painters of the French Academy on his work.

*33. **Antelope Hunters, Texas , 1887**, oil on canvas, 22-3/4 x 36-1/8"*

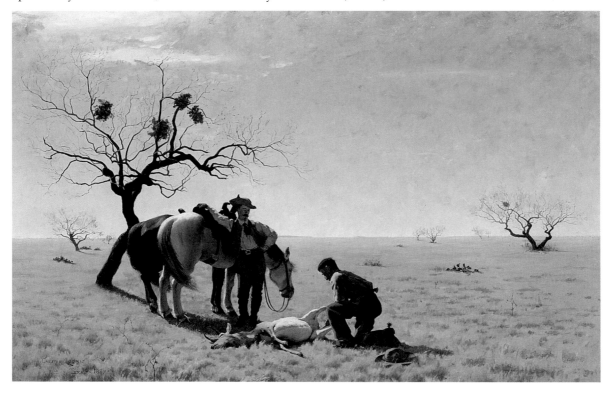

HUBERT VOS

(MAASTRICHT, HOLLAND 1855-NEWPORT, RHODE ISLAND 1925)

From the time he was a schoolboy, Vos wanted to be an artist, but the premature death of his father forced him to seek work. He entered the printing-publishing business for some time and then abandoned it to study art. He began his studies at the Royal Academy of Brussels under Portaels. From there he went to Paris and Rome to study and then returned to Belgium where he completed his studies at the Royal Academy. Afterwards he sought a teaching position in Belgium but was unsuccessful. So he went to London where he opened an art school for men based on the atelier system. His school was so successful that he was able to open two more studios — one for ladies and one for more advanced students. Vos spent ten years in London, during which time he founded the Society of Portrait Painters and the Society of Pastelists.

A turning point in Vos' career came in 1892 when he was appointed Deputy Commissioner to represent the Royal Commissioner for Holland at the World's Fair in Chicago. The United States made such an impact on him that he decided to stay. He became an American citizen and established his studio at various intervals in New York City, Washington, D. C., Bar Harbor, Maine, and Newport, Rhode Island. His reputation as a portraitist grew and his canvases were in increasing demand.

While working at the Chicago World's Fair, Vos witnessed the congress of the peoples and conceived the idea of acquainting himself with the aboriginal races of the world. He embarked on a world tour in order to accomplish his goal of studying pure racial types. He traveled first to Korea, China and Java and then on around the world. Upon his return to the United States, he exhibited his canvases at the Union League Club in New York, at the Corcoran Art Gallery in Washington, D. C., at the Buffalo World's Fair and later at the International Exhibition of 1900 in Paris. Vos's first attempt at capturing different racial types led him on a quest for the most characteristic tribes of the rapidly disappearing

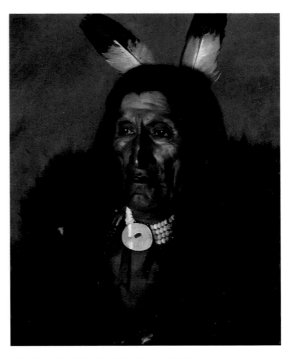

34. **Sioux Chief in Buffalo Robes** (1897), oil on canvas, 24 x 20"

American Indian. He obtained a letter of introduction to the Indian Agents and then visited some of the principal Indian settlements. *Sioux Chief in Buffalo Robes* (1897) represents one of the Native American types that Vos established. The portrait depicts more an idealized subject than it does a particular individual. The artist shows the same chief variously garbed in order to suggest the different roles a tribal leader must assume — judicial advisor, wise man and mediator.

EDWARD HENRY POTTHAST

(CINCINNATI, OHIO 1857-NEW YORK, NEW YORK 1927)

By age sixteen, Potthast was already listed as a lithographer in Cincinnati's City Directory. In 1879 he hired on with Strobridge Lithography Company where he worked intermittently for the next fourteen years. Around the same time, he took evening classes at the McMicken School of Design until 1882 when he and fellow Cincinnati artists, Joseph Henry Sharp and Charles Haider, departed for Europe. There he studied first in Antwerp and then in Munich. Potthast returned to Cincinnati, resuming work at Strobridge and enrolling in evening classes at the Cincinnati Art Academy. Around 1889, the artist made a second trip to Europe and studied the next years in Paris and Munich. During this time he was influenced by the French impressionists and exhibited both at the Paris Salon and in Munich.

Following his return to Cincinnati in 1895, Potthast spent the summer in New York. He moved there the following year and worked initially as a lithographer for *Scribner's* and *Century* magazines. He later decided to devote himself to painting. By 1908 Potthast had become successful enough to afford his own studio which overlooked Central Park. He was accepted by the New York art establishment and was a member of the Society of American Artists, the National Academy of Design and the Salmagundi Club.

Potthast devoted himself to painting New York's beach life with its varied themes, such as children romping in the surf while their mothers look on, or family groups picnicking or sunning themselves. The seashore paintings are the artist's best known body of works. He received critical acclaim for them, although he was sometimes criticized for a lack of variety.

Potthast made two western sojourns. On his first trip in 1910, he and four other artists (among them Thomas Moran and Elliott Daingerfield) were chosen by the Atchison, Topeka and Santa Fe Railway to paint the splendors of the Grand Canyon.

One of their traveling companions, Mrs. Nina Spalding (then Assistant Director of the Toledo Art Museum) wrote:

Never before had so large a group of serious artists made such a pilgrimage to the Far West with the avowed intention of studying a given point of their own country, and thus will this visit to the Canyon become historical...The painters worked all day and sometimes half the night, wandering far upon the rim in search of ivory cliffs, characteristic trees and bits of composition.

The Grand Canyon (no date), a studio painting the artist composed from sketches made on the 1910 trip, shows off the bright palette that identifies Potthast with the American Impressionists.

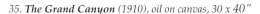

35. **The Grand Canyon** *(1910), oil on canvas, 30 x 40"*

JOSEPH HENRY SHARP

(BRIDGEPORT, OHIO 1859-PASADENA, CALIFORNIA 1953)

Sharp began his art study at the McMicken School of Design (later the Cincinnati Art Academy). In 1881 he took the first of many trips abroad to visit museums and to study art.

Beginning in 1892, Sharp taught at the Cincinnati Art Academy during the winter months and journeyed west to paint in the summer. Around this time, while working as an instructor, he met Henry Farny who revived his interest in Indians. A year later, Sharp traveled to the West with fellow artist, John Hauser, and made his initial trip to New Mexico. He was captivated by the rugged landscape, the quality of light and the Indians. Sharp was back in Europe in 1895, where he met Ernest Blumenschein and Bert Phillips, young American artists then studying in Paris. He told them of the splendors of the Taos-Santa Fe area in northern New Mexico and encouraged them to travel there to paint. Thus, Sharp planted the seed for what later became the Taos Society of Artists.

He divided his next summers between the Plains Indians of Montana and the Pueblo Indians of New Mexico. In 1902, in order to spend time painting in the West, Sharp resigned from his teaching position at the Cincinnati Art Academy. After 1909, Sharp summered in Taos and wintered in Pasadena, California.

Sharp considered it his duty to record the Indian and his way of life which was undergoing major changes. He made his first major sale to the Department of Anthropology at the University of California and to the Bureau of Ethnology at The Smithsonian Institution. He had spent so many years studying the Indians with such empathy that his paintings have an emotional undertone which makes them more appealing than any straightforward anthropological recording.

Influenced by the writings of James Fenimore Cooper, Sharp had been interested in the Native American from boyhood. When questioned about his choice of the Indian as subject matter, the artist replied, "Perhaps they attracted me as subjects because of their important historical value as the first Americans. Then the color of their costumes and

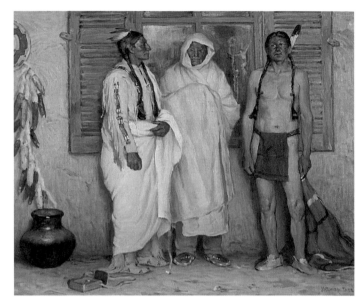

36. *Three Taos Indians* (no date), oil on canvas, 25 1/4 x 30 1/4"

37. *Winter Encampment on the Plains* (1919), oil on canvas, 24 x 36-1/8"

dances, this no less attracted me." *Three Taos Indians* (no date) shows Sharp's Indian models dressed in Plains Indian attire. The artist had a large collection of Indian costumes and accoutrements that he used as props in his paintings.

In 1902, in order to fulfill Phoebe Hearst's commission for paintings of notable Indian tribes (earmarked for the University of California, Berkeley), Sharp moved to Montana. The Crow Agency there was the logical location for portraying Plains Indians. Rendered in lighter impressionist tones, *Winter Encampment on the Plains* (1919) is based on Sharp's Montana years.

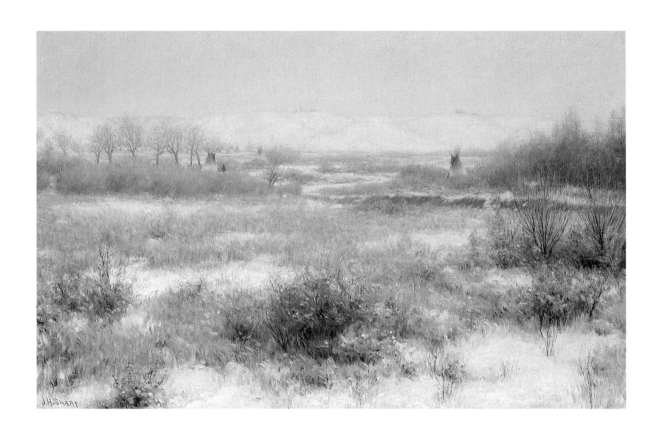

FREDERIC REMINGTON

(CANTON, NEW YORK 1861-RIDGEFIELD, CONNECTICUT 1909)

Like many country boys of his era, Remington spent his youth pursuing the masculine endeavors of hunting, fishing and riding. In 1878, he entered Yale University where he studied art and played football. He continued his studies for a brief period at the Art Students League under J. Alden Weir, one of the founders of the American Impressionist movement. In 1881 Remington traveled to the West, the land of his dreams, and tried his hand at sheep ranching. This was an unsuccessful venture and eventually he turned to a career in art. He made numerous sketches while in the West, one of which he sold to *Harper's Weekly*. Remington then devoted his career to one of the most American subjects — the West — and soon other publications such as *Outing Magazine*, *Century* and *Scribner's* demanded as many illustrations as he could produce. As a result of regular assignments from these magazines, Remington made several more sketching trips west, each time gathering material about frontier life for later use in his writings, illustrations and paintings.

Between 1881 and 1907 he produced nearly 3,000 illustrations, paintings and sculptures. In addition he had two novels and five collections of stories and essays to his credit. The West that Remington reported was partially of a by-gone era. His art so dominated the American imagination, that a mythos grew out of it which historians are still sorting out.

38. The Quest (circa 1902), oil on canvas, 26 x 39-1/2"

Remington entered *Return of the Blackfoot War Party* (1887) in the 1888 National Academy of Design exhibition where the painting was awarded a gold medal. Hoping to shed his image as an illustrator, this was one of his first attempts to win public recognition among his peers as a fine artist.

The artist had wanted his tombstone to read, "He knew the horse." To Remington horses and action were synonymous, as in *Turn Him Loose, Bill!* (1891), which juxtaposes man and beast. This painting was typical of the exciting, narrative style which characterized the artist's early work.

The Quest (alternatively titled *The Advance*, 1901) depicts the military, one of the artist's favorite subjects. This painting is typical of the sunlit scenes Remington painted after 1900 when he adopted a lighter, more impressionistic palette.

39. Turn Him Loose, Bill! (1892), oil on canvas, 25 x 33"

40. Return of the Blackfoot War Party (1887), oil on canvas, 28-1/2 x 50"

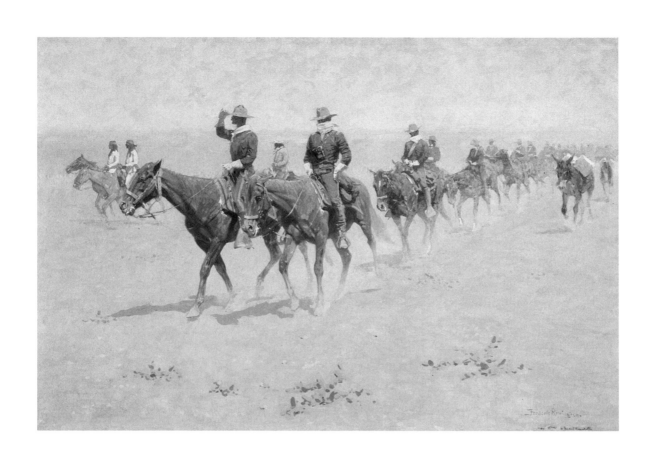

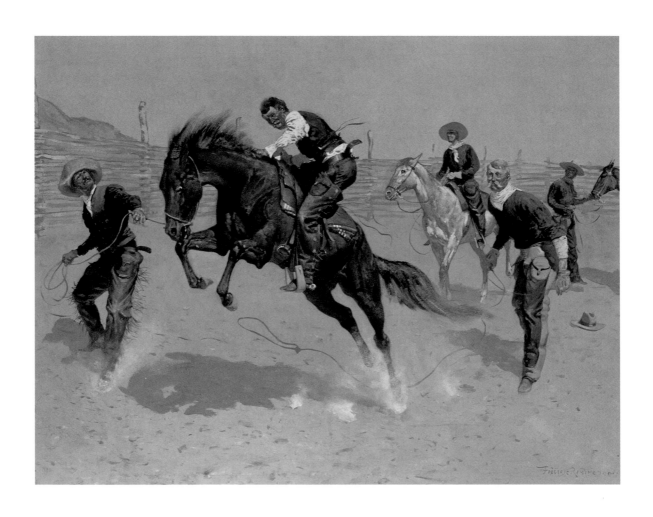

70

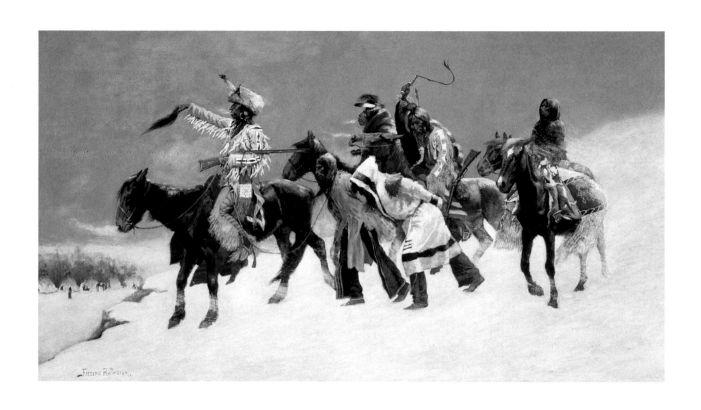

CHARLES SCHREYVOGEL

(NEW YORK, NEW YORK 1861-HOBOKEN, NEW JERSEY 1912)

After his family moved to Hoboken when he was a young boy, Schreyvogel had to find employment due to the family's financial situation. He became apprenticed to people in art-related trades and taught himself to draw. He progressed quickly and soon earned extra money by teaching drawing and painting.

In 1887 two patrons enabled the artist to go abroad for formal art study in Munich. He studied

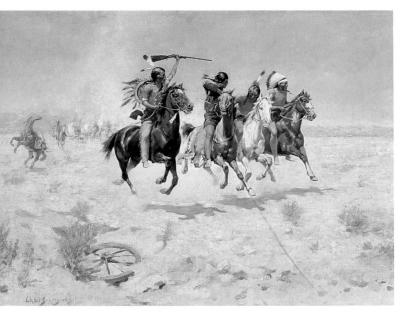

*41. **The Attackers** (circa 1900), oil on canvas, 25 x 34"*

for three years with Carl Marr and Frank Kirchbach. Upon his return home Schreyvogel was advised to go west for his health. Only three years later did his financial situation allow him to do so. In the interim, the West came to him in the form of Buffalo Bill's Wild West Show. He sketched the Indians and cow

boys while they were in New York; and when Buffalo Bill Cody saw his work, he encouraged the artist to continue with his artistic endeavors.

In 1893 Schreyvogel made his first trip to the West: to Colorado and Arizona. At Ignacio, the large Ute reservation in southwest Colorado, he regained his health, became a fine horseman and learned sign language, which he used to persuade the Indians to pose for him. Schreyvogel's concern for authenticity led him to collect sketches, casts and photographs of his subjects while in the West. His careful study of both Indians and soldiers resulted in the accurate depiction of Indian war regalia and of military accoutrements.

Upon his return home, the artist found no market for his interpretations of the United States Army's encounters with the Indians. In 1900 he entered one of these works, *My Bunkie*, in the National Academy's annual exhibition. The canvas depicts a cavalryman's heroic rescue of his fellow trooper. Because he had little hope of winning, he was amazed when his painting won the highest honor. This recognition brought him the success which enabled him to return to the West for fresh material.

Schreyvogel portrayed the conflict between the Indians and the military in the waning days of the frontier. His paintings often portray the violence which occurred in the settling of the frontier West. In *The Attackers* (alternatively titled *In Hot Pursuit*, circa 1900) a band of hostile Indians are pursued by troopers after setting fire to a wagon train. This was one of the Indians' many attempts to stop the encroachment of the white man. *A Sharp Encounter* (1901) illustrates the terror of hand-to-hand combat as cavalrymen and Indians alike brace themselves for the attack. In this case, the Indians are defending their tepee village, barely visible in the upper left-hand corner, and easy to miss for all the action in the painting's foreground.

*42. **A Sharp Encounter** (1901), oil on canvas, 25 x 34"*

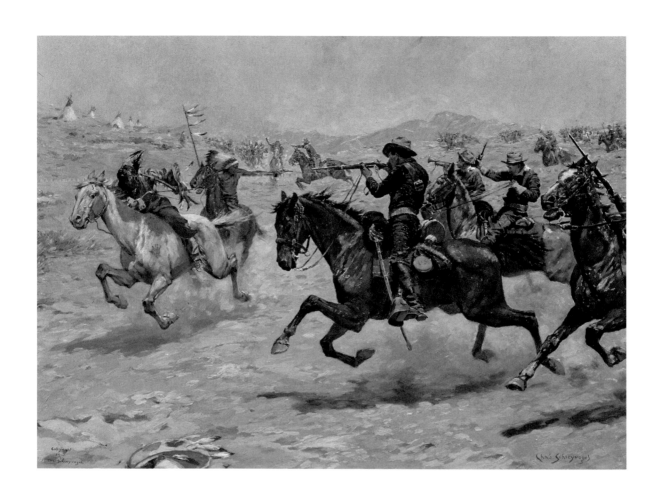

CHARLES MARION RUSSELL

(ST. LOUIS, MISSOURI 1864-GREAT FALLS, MONTANA 1926)

As a boy, Charles Marion Russell dreamed of becoming a frontiersman like his great-uncle, William (Will) Bent. He loved to draw and his earliest known pictures show warbonneted Indians on horseback. Shortly after his sixteenth birthday, his parents sent him to Montana. They hoped that a first-hand experience with ranching would cure their son of his romantic notions about the West. Instead, Russell fell completely under its spell and spent the next seven years working either as a horse

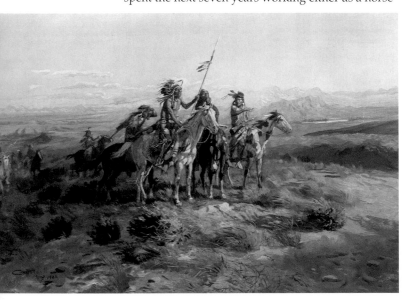

43. **The Scouts** (1902), oil on canvas, 24 x 36"

wrangler or as a night herd rider. He carried his watercolors in his bedroll so that he could paint whenever he had a spare moment.

Russell spent the winter of 1888 among the Blood (Blackfeet) Indians of Alberta, Canada. He lived among them as a brother; the chief even encouraged him to take an Indian wife. The artist studied their language and learned their tribal legends. In his paintings, Russell immortalized both the Indians and the cowboys with whom he lived and

worked. One of his early works, *Caught in the Act*, was published in *Harper's Weekly* (1888). It shows two mounted cowboys confronting a starving Indian family. The Indians are seen butchering a white man's steer out of desperation, because their food source — the buffalo — had been decimated by the white man just a few years earlier.

In 1890, fourteen of Russell's early oils were published in a small folio entitled *Studies of Western Life*. That same year he was commissioned to decorate the iron door of a bank in Lewiston, Montana, with mural representations of ranch life. It was not until his marriage to Nancy Cooper that Russell really pursued art as a career. She became his business manager and negotiated good prices for his work. In the years that followed, his popularity as an illustrator increased and he was besieged with commissions. His illustrations were sold to various weekly magazines and his paintings to Hollywood film stars and oil tycoons. Charlie Russell is probably the West's best-loved artist, known for his humor and for his accurate depiction of ranch life in the 1880s and 1890s.

A good draftsman, Russell was basically self-taught. As he learned more about color, he used more white in mixing his colors which lightened his palette. As he learned more about composition, he employed the classical pyramid configuration. Both techniques are evident in *The Scouts* (1902), which is done in lighter pastels with the chief's white horse serving as the focal point. The chief's spear functions as the apex of the pyramid.

ROBERT HENRI

(CINCINNATI, OHIO 1865-NEW YORK, NEW YORK 1929)

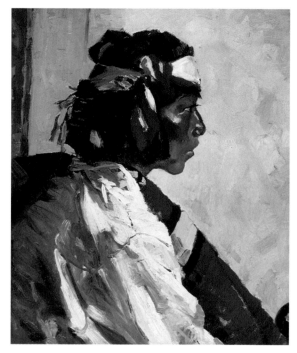

44. *Miguel of Tesuque* (1917), oil on canvas, 24 x 20"

Robert Henri began his art education at the Pennsylvania Academy of Fine Arts in 1886, where he studied under Thomas Anshutz and Thomas Hovenden. In 1888 he journeyed first to Paris for study at the Académie Julian under Bouguereau and Robert-Fleury and then to Brittany for independent study in 1889. Returning to the United States in 1891, he exhibited at the Pennsylvania Academy of Fine Arts and began his teaching career. During this time young artists, including John Sloan, Everett Shinn, George Luks and Williams Glackens, met in Henri's studio, which became an unofficial annex to the Academy.

Henri went back to France in 1895. He lived in Paris until 1900, when he returned to make New York his permanent home. He taught at the New York School of Art from 1902 to 1908 and was elected a member of the National Academy of Design in 1906. In 1908 Henri and his reassembled group of Philadelphia friends and former students, along with Ernest Lawson, Arthur B. Davies and Maurice Prendergast, held a group exhibition of their own to protest the prevailing rigid conservatism of the National Academy of Design. This exhibition of "The Eight" or "The Ashcan School", as they were known, had widespread consequences. It heralded a new school of American painting and paved the way for the historic Armory Show of 1913, which exposed America to the European modernist movement. Henri's efforts impacted the course of American art history, bringing it into the twentieth century. Henri devoted his remaining years to painting and teaching. He continued to support and encourage the modern American art scene. In 1923 he published *The Art Spirit*, his philosophy of art and teaching. When he died, he left a legacy of disciples in addition to his writing and painting.

In 1916 Henri traveled to New Mexico. He renewed his acquaintance with ethnologist, Edgar L. Hewett, who introduced the artist to the New Mexican Indians and their culture. These ethnic people and the clear sun-drenched atmosphere brought Henri back to the region two more times. In 1917 he rented a house in Santa Fe and made excursions to Acoma and Taos to witness Indian ceremonial dances. His praise for the area prompted fellow painters George Bellows and Leon Kroll to join him in Santa Fe that summer. Henri visited New Mexico for the last time the summer of 1922. For Henri, the pueblos and Indians represented the last vestiges of a noble, primitive civilization. He captured their essence in powerful portraits like *Miguel of Tesuque* (1917).

WILLIAM ROBINSON LEIGH

(BERKELEY COUNTY, WEST VIRGINIA 1866-NEW YORK, NEW YORK 1955)

William Robinson Leigh began drawing at an early age. He studied for three years at the Maryland Institute of Art in Baltimore, before setting off for Europe. He spent most of his twelve years there studying at the Royal Academy in Munich. After his return to New York in 1897, Leigh made his reputation as an illustrator for leading national magazines.

During the summer of 1897, Leigh fulfilled his childhood dream of going west when *Scribner's* sent him on assignment to North Dakota. Over the next twenty-nine years, the artist returned often to the West, sometimes on assignment and other times of his own volition. On his first trip to the Southwest in 1906, Leigh visited the villages of Zuni and Acoma, met Joseph Sharp in Taos and went on as far as the Grand Canyon in Arizona. The subject of his latter period in the West was the land of the Hopi and the Navajo, painted with the southwestern palette of soft pinks, purples, reds and yellows. The majestic *Grand Canyon, 1908* glows with the sunwashed pinks and yellows for which Leigh became known. His critics, who had never been west, complained that his colors were too garish.

Leigh traveled to Africa in 1926 and 1928. He used the sketches and paintings from these trips for illustration purposes. In his later years, he executed historical murals. He continued to paint western subjects, which were in high demand. Leigh used his earlier compositions as sources of inspiration for his later works. After his death, the contents of his studio were given to the Gilcrease Institute in Tulsa, Oklahoma.

*45. **Grand Canyon 1908**, oil on canvas, 35-1/2 x 59-1/2"*

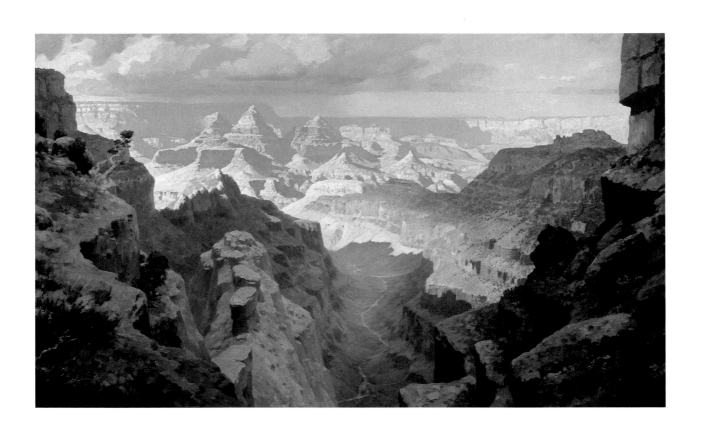

EANGER IRVING COUSE

(SAGINAW, MICHIGAN 1866-ALBUQUERQUE, NEW MEXICO 1936)

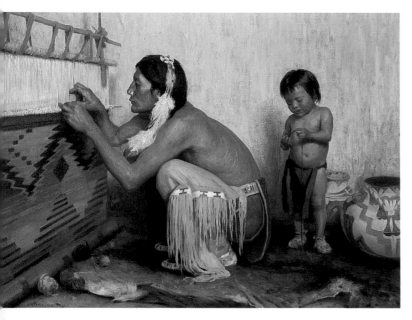

47. **Indian Weaver** (1914), oil on canvas, 38 x 50"

Couse knew from an early age that he wanted to be an artist. He studied at the Art Institute of Chicago and the National Academy of Design in New York before journeying to Paris to study at the Académie Julian. There he developed artistically under the academic painter, Adolphe Bouguereau. Couse's academic training stayed with him throughout his life. Even the southwestern Indians painted in later life look like classical models.

In Paris, Couse met Joseph Sharp and Ernest Blumenschein. These men shared a common vision: that American art ought to seek American subject matter. For this they needed fresh material. These artists decided to paint Indian subject matter since it was far removed from dominant mainstream art. Couse first went to Taos in 1902 and summered there every year until 1927 when he gave up his New York studio to settle permanently in Taos.

Couse created in his paintings an image of tranquil and beautiful Native Americans. His work was characterized by certain features which he used repeatedly due to their effectiveness. His Indian models are shown in profile, generally crouching or squatting. They are scantily clad so that strong light

— usually firelight or moonlight — reflects off their well-muscled bodies. As in the painting *Indian Weaver* (1914), the model is most often engaged in some domestic activity.

In most of his work, Couse shows an obvious sympathy for his subjects. He probably fell victim to the taste for sentimental idealism, which prevailed during his most active period as an artist. Clearly Couse spoke to the sensitivities of his time, as signified by his commission with the Santa Fe Railway. Couse's paintings were featured on every calendar the railroad produced between 1922 and 1934. He created over 1500 oils over the span of his career, many of which hang in major American museums.

A literal and objective ethnographic recording, *Moki Snake Dance* (1904), is Couse's masterpiece. For this ceremony, the snakes are collected and confined for a few days to the kiva, a room devoted to religious rituals and tribal councils. The Indians dance on the last day of the ceremony, grasping the snakes in their mouths and using long feathers to mesmerize them. This eyewitness account of a traditional Hopi (Moki) midsummer rite is devoid of the romantic motifs which dominate much of Couse's other work.

46. **Moki Snake Dance** (1904), oil on canvas, 36 x 48"

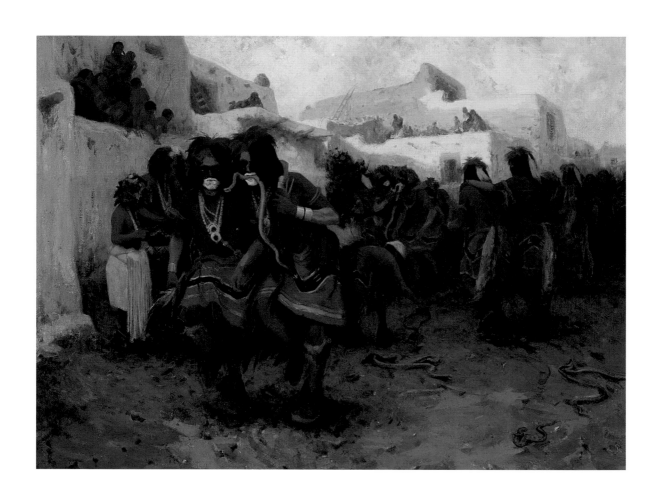

BERT GEER PHILLIPS

(HUDSON, NEW YORK 1868-SAN DIEGO, CALIFORNIA 1956)

Phillips left home at age 15 to study art. He worked for five years at the Art Students League and the National Academy of Design of New York. He traveled to Europe in 1894 where he went on a sketching trip through England and continued his studies at the Académie Julian in Paris. There he met Ernest Blumenschein, another young American artist. Thus began a friendship that was to last a lifetime. The two young men met another American, Henry Sharp, who described northern New Mexico's varied landscape and subject matter.

In the summer of 1898, Phillips and Blumenschein arrived in Denver. From there they made sketching trips to the Colorado Rockies. When autumn approached, they bought a team and wagon and headed south, planning to travel to Mexico. The ensuing story of their founding the Taos artists colony has its roots in a much-told tale of a broken wagon wheel. After casting lots, Phillips remained with the wagon while Blumenschein, astride one of the horses, took the wheel for repair to the nearest blacksmith shop, which was in Taos. Both men were so entranced by the scenery and the people of New Mexico that they abandoned their trip to Mexico, sold their wagon and horses and rented a studio in Taos.

Blumenschein's commitments in New York forced him to leave in the late autumn, but Phillips decided to stay. He became the mainstay of the Taos artists group and was instrumental in the formation of the Taos Society of Artists. This association was set up to prompt sales and exhibitions in other parts of the country since Taos was so remote. From the beginning, the Taos Society of Artists' traveling shows were a commercial success. They also provided publicity for this little-known region. Due to the favorable impression produced by the Taos Society's exhibitions, artists from other regions in the United States were attracted to New Mexico.

Phillips' style has been described as lyrical and also as mythical and visionary. New Mexico had a profound effect on his work. *El Palacio* (July, 1920)

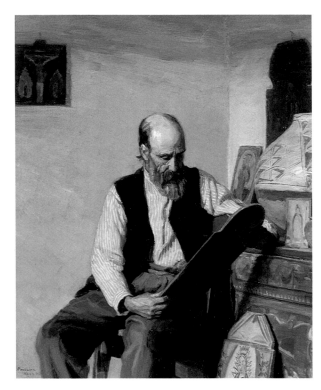

48. **The Santero** (circa 1918), oil on canvas, 30 x 25-1/4"

quoted the artist as saying: "...I believe that it is the romance of this great pure-aired land that makes the most lasting impression on my mind and heart."

The Santero (circa 1918) is a portrait of the artisan who makes religious figures of saints. He is shown examining a finished image of a saint painted on a board.

CARL RUNGIUS

(BERLIN, GERMANY 1869-NEW YORK, NEW YORK 1959)

Rungius received his formal art training in Berlin where he attended various art schools, among them the School of Applied Arts and the Berlin Academy of Fine Art. One of Rungius' instructors at the Academy, Friedrich Meyerheim, was a wildlife painter. He encouraged the young artist to become an animal painter. This effort was supported by Rungius' grandfather who also painted animals and was an amateur taxidermist.

In 1894 Rungius traveled to the United States so he could join his uncle on a hunting trip to the West. He remained in the region to paint through the summer of the following year. He sketched in Yellowstone National Park and other parts of Wyoming. The artist returned to New York from his first Wyoming venture in 1895. The spring of the following year he returned to Germany to visit his family and bid them farewell. He said that his decision to cut ties with the Old World and to live in America for good was due to his first Wyoming trip: "For my heart was in the West." Rungius returned to Wyoming every summer and fall through 1902.

During his first years in America, Rungius illustrated for the popular magazines of the day. He specialized in painting the outdoor scene, portraying activities like hunting, fishing and camping. He also depicted nearly every North American big game species for such periodicals as *Forest and Stream* and *Outing Magazine*. By 1904 Rungius had begun to devote himself to serious painting. He had been accepted into the New York art community and was a member of the Salmagundi Club. In 1913 he was elected an associate member of the National Academy of Design. He became a full member in 1920.

Rungius specialized in big game painting—moose, bear and elk as well as mountain sheep and goats, deer and elk. After the turn of the century, conservation laws went into effect, and ranches and settlements replaced the old hunting grounds the artist had known. He returned to Wyoming in 1915 and observed: "Since there was no big game left there for studies I painted horses, cattle and landscape....I rode with a couple of round-ups, making sketches and photographs from the saddle." *In the Sagebrush* (before 1935) grew out of Rungius' latter western experience. This painting shows off his bold, fluent brushwork as well as his facility in handling both animals and the landscape.

49. **In the Sagebrush** (before 1935), oil on canvas, 28 x 40"

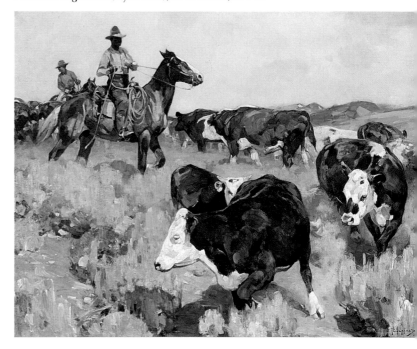

JOHN MARIN

(RUTHERFORD, NEW JERSEY 1870-CAPE SPLIT, MAINE 1953)

In 1899 John Marin abandoned architecture and enrolled at the Pennsylvania Academy of Fine Arts in Philadelphia, where he studied under Thomas Anshutz. He later was a student at the Art Students League in New York under Dumond. In 1905 Marin went to Europe and began to develop one of the most original American styles of modern

50. *Canyon of the Hondo, New Mexico* (1930), watercolor, 15-1/4 x 20"

painting. Alfred Stieglitz, the great American promoter of modern art and photography, was among the first to recognize the singular quality of Marin's art, and regularly exhibited the artist's work at his Gallery 291 in New York. Marin lived in New York City and summered in Maine. Therefore rhapsodic cityscapes and the Maine seacoast are the subjects that comprise most of his work.

At the suggestion of Georgia O'Keeffe and Mrs. Paul Strand (Rebecca James), Marin spent the summers of 1929 and 1930 in New Mexico. He sought and found new subject matter in the environs of Taos, and thus expanded his pictorial vocabulary. From these two trips he produced more than one hundred watercolors which were the subject of his one-man show at the Museum of Modern Art in New York in 1936. He exerted a strong influence on Victor Higgins, Ward Lockwood, Kenneth Miller Adams, Andrew Dasburg and other New Mexico painters.

While painting in the Taos region, he concentrated on capturing the intense New Mexico light and the way it emphasized the landscape, as seen in *Canyon of the Hondo* (1930). Marin once said to a friend: "If you think you know what light is then go to New Mexico and you'll find a quality of light many times more intense than anything you get in New York, or Maine, or the White Mountains." As evident in *Blue Sky, Mountain Aspens and the Roaring Hondo, New Mexico* (1930), Marin simplified forms and emphasized the landscape directly in his line of vision.

51. *Blue Sky, Mountain Aspen, and the Roaring Hondo, New Mexico* (1930), watercolor, 19-1/2 x 15"

JOHN SLOAN

(LOCK HAVEN, PENNSYLVANIA 1871-HANOVER, NEW HAMPSHIRE 1951)

As a young man, John Sloan demonstrated artistic promise which his family supported. His uncle often showed him his large collection of prints by such European artists as Hogarth and Cruikshank. At age 13 Sloan illustrated his own copy of *Treasure Island*. In 1887 he began work for Porter and Coates, booksellers and fine print dealers in Philadelphia, where he found a market for his drawings and greeting cards. The following year Sloan taught himself to etch from *The Etcher's Handbook*. Subsequently he did free-lance design work and advertising. In 1892 he was employed in the Art Department of the *Philadelphia Inquirer*. Later he worked for ten years as an artist-illustrator for the *Philadelphia Press*. 1892 was a momentous year in Sloan's life — he met Robert Henri while enrolled in a class at the Pennsylvania Academy of Fine Arts. The two men remained close associates for life. Sloan was never formally enrolled as Henri's pupil, but the older man proved to be the greatest single influence on Sloan's life as well as on his art. In 1897, inspired by Henri, he began to paint seriously, concentrating mainly on portraiture. For more than a decade, his painting reflected Henri's manner and spirit.

In 1904 Sloan moved to New York. The following year he began a series of etchings on city life. He became a member of "The Eight" and participated in its exhibition at the Macbeth Gallery in 1908. Together with Robert Henri, Sloan helped organize the Exhibition of Independent Artists of 1910. This became an annual event which foreshadowed the Armory Show of 1913. Sloan showed seven of his paintings in this historic exhibition.

Beginning in 1916, Sloan taught at the Art Students League to supplement his income. A popular teacher, he influenced a generation of American painters. Some of them, such as Reginald Marsh and Adolf Gottlieb, later became leaders in the art world. Like many artists and teachers of his time, Sloan was brought up with a sense of responsibility to the next generation. He conveyed this to his students: "...The artist must be interested in truth, in goodness, in order. He must care about people more than about making art..." In 1939 Sloan published *Gist of Art*, a book on his philosophy and teaching of art.

In 1919 he took Henri's advice and summered in New Mexico. From 1920 until his death he spent every summer there except for the years 1933 and 1951. Sloan played an instrumental role in the New Mexico art scene. He encouraged young artists, promoted exhibitions of Native American art in the East and advised the newly established art museum in Santa Fe. His work in New Mexico took on a new coloristic freshness. He wrote: "I like to paint the landscape of the Southwest because of the fine geometric formations and handsome color...Because the air is so clear you feel the reality of things in the distance." *Chama Running Red* (1925) is among the best of his New Mexico paintings. Sloan describes this piece in *Gist of Art*: "The River is running like pink tomato soup down to the Rio Grande and the Gulf of Mexico, carrying off the good red earth."

52. ***Chama Running Red*** *(1925), oil on canvas, 30 x 40"*

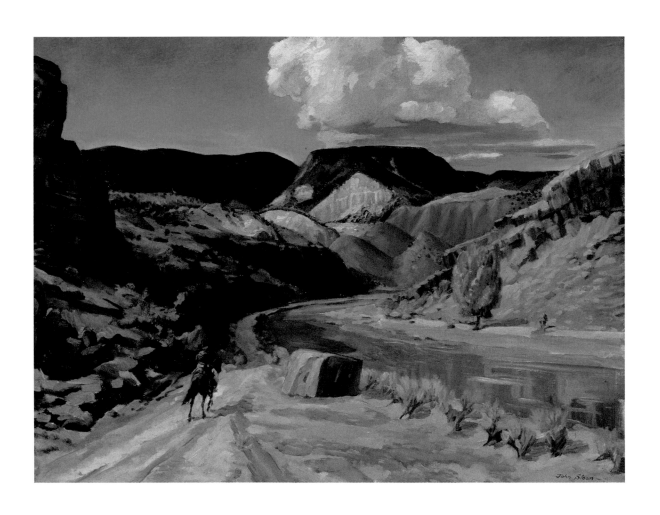

ERNEST LEONARD BLUMENSCHEIN

(PITTSBURGH, PENNSYLVANIA 1874-ALBUQUERQUE, NEW MEXICO 1960)

Blumenschein was born into a musical family and therefore spent his early years studying both music and art. While at the Art Students League in New York, he supported himself by working as a symphonic violinist. In 1894 he played first violin under the visiting conductor-composer Antonin Dvorák.

In 1895 Blumenschein studied at the Académie Julian in Paris where he met Bert Phillips and Henry Sharp. The latter described the scenery and people he had sketched around Taos, New Mexico to the two younger artists and encouraged them to travel to the region. Blumenschein and Phillips went to Taos in 1898 and found it equal to Sharp's description.

Beginning in 1909 Blumenschein divided his time between Taos and New York, until he moved his family to New Mexico in 1919. While in New York, he taught at the Art Students League and collaborated on illustrations with his artist wife, Mary Shepard Greene. He also did studio painting and entered various juried competitions.

Considered the "intellectual" of the Taos Society of Artists, Blumenschein was in touch with the modern art movements of his day and adopted elements from them that best suited his subjects and style. He is among the best known of the early Taos artists because his work traveled widely and received the most acclaim during his lifetime.

Church at Ranchos de Taos (before 1919) shows the influence of the artist's teacher, Benjamin Constant (Académie Julian), who had painted genre scenes of Morocco. Blumenschein achieves a universal quality with this dramatic narrative painting. This rendition of the St. Francis of Assisi church was reproduced in 1972 on the Santa Fe Railway's menu cover.

Blumenschein's work changed under the influence of the Southwest. His palette became brighter and he abandoned his illustrative style in favor of a mystical, intuitive portrayal of Indian and Hispanic subjects. His work became increasingly decorative

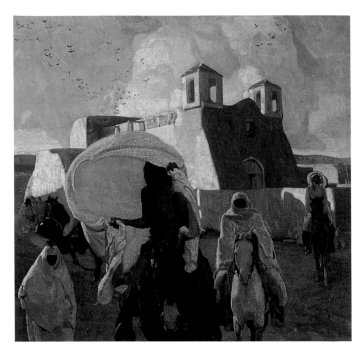

53. **Church at Ranchos de Taos** (before 1917), oil on canvas, 45 x 47"

and he sought textural qualities to embellish his rugged landscapes. These qualities are evident in the massive rolling mountains in the background of *Sangre de Cristo Mountains* (1927), a stylized and intricately-patterned painting and one of the artist's masterpieces. (Blumenschein himself rated this work as one of his ten best paintings.) The power and majesty of the mountains contrasts with the human scale of the penitentes procession in the foreground. The artist's mystical vision emerges as he comments on the transitory nature of man, and the enduring nature of the mountains — and art.

54. **Sangre de Cristo Mountains** (1925), oil on canvas, 50-1/4 x 60"

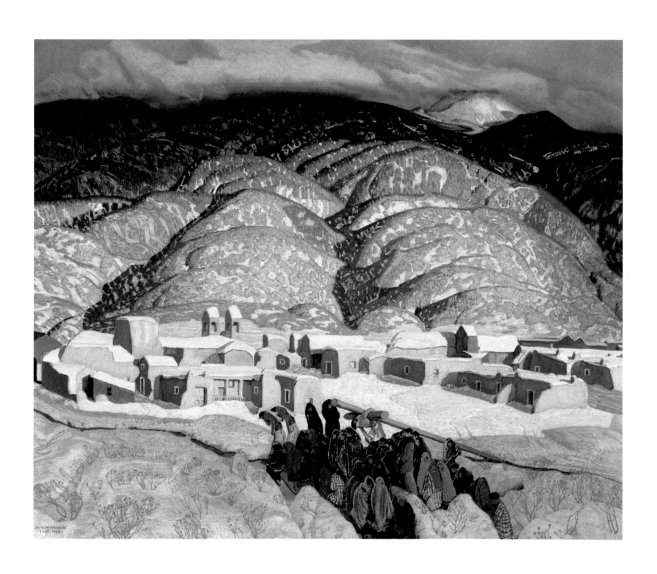

OSCAR EDMUND BERNINGHAUS

(ST. LOUIS, MISSOURI 1874-TAOS, NEW MEXICO 1952)

As a young man Berninghaus spent his days working for a lithographer and his nights attending classes at the St. Louis School of Fine Arts. In 1899 he was given a paid vacation, which he spent traveling by train through Colorado and into New Mexico. He had heard of the beauty of Taos and traveled there by buckboard from the train junction. During the week he spent in Taos, he met Bert Phillips, who had already established himself in the picturesque village. Phillips invited Berninghaus to return the following year. So began his practice of spending the winter months working as a commercial artist in St. Louis and the summer as an easel painter in Taos. In 1912, Berninghaus joined the founding members of the Taos Society of Artists and subsequently sent his paintings on the group's circuit shows. In 1919 Berninghaus bought a house in Taos, but continued his dual career commuting between Missouri and New Mexico until 1925. At that time he moved permanently into his rambling adobe home on the hill overlooking the village.

His experience as a lithographer made Berninghaus an excellent draftsman. He excelled at drawing animals in the southwestern landscape and in creating paintings with clearly defined spaces. In his earliest Taos paintings, he placed man in nature, but not in the dominant position. It was his vision to draw man in relation to nature. His later paintings, using a broader scope and a larger scale, show man smaller in relation to his surroundings. Some of that scale and impact is evident in *Winter Hunt* (1917), which depicts the desolation of the Indians who are forced to search for game under a cold, leaden sky.

Berninghaus felt that the artists in Taos were filling a historic niche. In a newspaper interview (1927) he said: "I think the colony in Taos is doing much for American art. From it will come a distinctive art, something definitely American. We have had French, German, Italian, and Dutch art. Now we must have American art. I feel that from Taos will come that art."

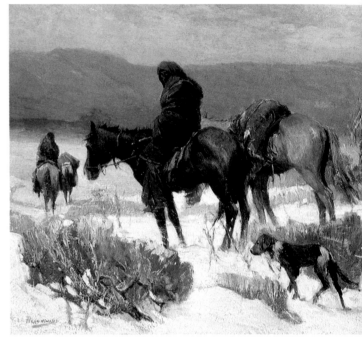

55. **Winter Hunt** (1917), oil on canvas, 22 x 28"

MAXFIELD PARRISH

(PHILADELPHIA, PENNSYLVANIA 1870-PLAINFIELD, NEW HAMPSHIRE 1966)

Parrish's artistic talents were encouraged as a youngster. He accompanied his parents on an extended tour of Europe from 1884 to 1886 where he was exposed to museums, architecture and music.

Parrish pursued art studies from 1892 to 1894 at the Pennsylvania Academy of Fine Arts and later took some classes with Howard Pyle at the Drexel Institute. From 1894 to 1898 he occupied various studios while working in Philadelphia.

In 1895 Parrish launched his illustrating career with the production of his first national magazine cover for *Harper's Bazaar*. That summer he spent two months in Europe visiting museums and galleries, and studying Old Master and French Impressionist paintings. In 1897 he exhibited at the Society of American Artists in New York and was elected to membership shortly thereafter.

Deadline pressures and constant interruptions caused Parrish to leave Philadelphia for Cornish, New Hampshire, where he built his studio, "The Oaks," in nearby Plainfield. He had first visited the budding artist colony in 1896. Cornish Colony served as a meeting ground for creative minds — such as sculptor Paul Manship, painter Kenyon Cox and author Hamlin Garland — and the summer community would gather for parties, concerts and theater productions, for which Parrish designed sets and costumes.

Over his distinguished sixty-five-year career, Parrish illustrated for such leading national magazines as *Ladies Home Journal* and *Life*. From 1918 to 1963 he provided paintings for General Electric's and Brown and Bigelow's calendars. He designed posters, illustrated children's books and painted murals. New York's old Knickerbocker Hotel commissioned his first public mural. His private mural patrons included Gertrude Vanderbilt Whitney and Irenée DuPont.

Parrish traveled to the West on three occasions. He spent time in Arizona initially to recover from tuberculosis (1901-1902), and then on commission from *Century* magazine. He wrote of his experience: "We ride to the tops of the mountains, and from there you see nothing but other mountains, and not a sign of a human being anywhere. You get a sense of freedom and vastness here that I never imagined existed." In 1920 a commission brought him to Colorado Springs where he made studies for the painting, *The Broadmoor Hotel*. The West's spectacular scenery and dramatic light had a profound effect on Parrish's painting. He began using more color as he had seen it in nature. This is reflected in *The Old Glen Mill* (1950) which was Brown and Bigelow's 1954 calendar subject.

*56. **The Old Glen Mill** (1950), oil on masonite, 23 x 18-1/2"*

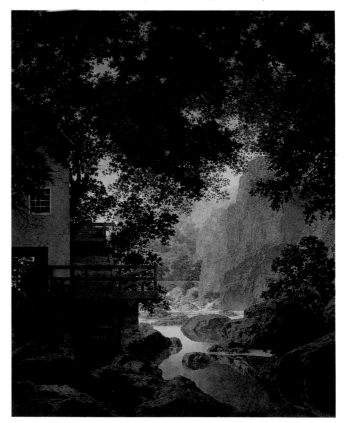

FRANK TENNEY JOHNSON

(BIG GROVE, IOWA 1874-ALHAMBRA, CALIFORNIA 1939)

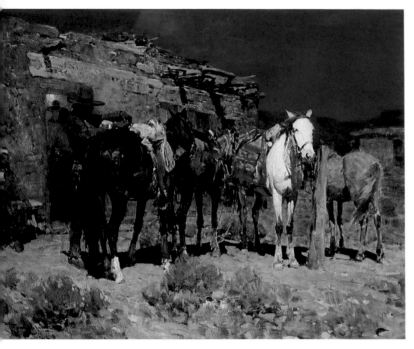

57. **Night at the Trading Post** (1928), oil on canvas, 36 x 46"

Born on a pioneer farm in western Iowa, Johnson recalled watching the prairie schooners cross the plains on their way to the West. When he was ten years old, the family moved to Milwaukee, Wisconsin. There he studied with F. W. Heine, whose specialty was painting horses. Fascinated by horses, Johnson never ceased studying them. He became famous for his accurate portrayals of the animal. Later he studied with Richard Lorenz, who was a member of the Society of Western Painters. Not only was Lorenz a good teacher, he imbued his pupil with his enthusiasm for the West.

Johnson spent several years painting portraits and working as a free-lance illustrator in Milwaukee. In 1902 he moved to New York and studied at the Art Students League. Robert Henri, William Merritt Chase, Kenneth Hayes Miller and F. Luis Mora were among his teachers.

In 1904 the magazine *Field and Stream* sent Johnson to Colorado and New Mexico. He spent the summer in Hayden, Colorado, where he joined up with two ranching outfits and participated in the spring and fall roundups. He observed and sketched the life of the cattleman. Intrigued with the West, Johnson decided to devote his art to the depiction of western scenes. *Field and Stream* was well satisfied with this work and commissioned more illustrations. As a result the artist made several more trips west. In 1905 Johnson met the Western novelist, Zane Grey, who contracted the artist to illustrate his novels. He illustrated for Grey for fifteen years, resulting in his growth to national prominence as an artist.

In 1920 Johnson settled in California. Around that time his easel paintings began to outsell his illustrations. There were increasing numbers of sales and commissions including the murals in a famous Los Angeles movie house, the Carthay Circle Theater.

Among the more important influences of the West on Johnson's painting were the landscape and the quality of light of the western sky, both by day and by night. He took notes on the subtle differences that the light made playing off the landscape and rocks in the moonlight. He also studied the technique of painter, Maxfield Parrish, whose cobalt blue skies Johnson admired. Johnson developed a special underpainting to give his nocturnal paintings a naturalistic quality of light, as evident in *Night at the Trading Post* (1928). While working as a cowpuncher in Colorado, Johnson wrote to his wife (letter dated July 21, 1904): "...on one evening in the cool mountain air as we rode I watched the daylight fade and the moon come up to glow brighter until we cast strong shadows...I had another fine opportunity to study the different colors change under the moonlight." In *Riders of the Dawn* (alternately titled *Riders of the Flat Top Ranch*, 1935) the artist shows his virtuosity in handling the changing light of day. The group of riders on an early morning reconnaissance could have been featured on the cover of a Zane Grey novel.

58. **Riders of the Dawn** (1935), oil on canvas, 48 x 60"

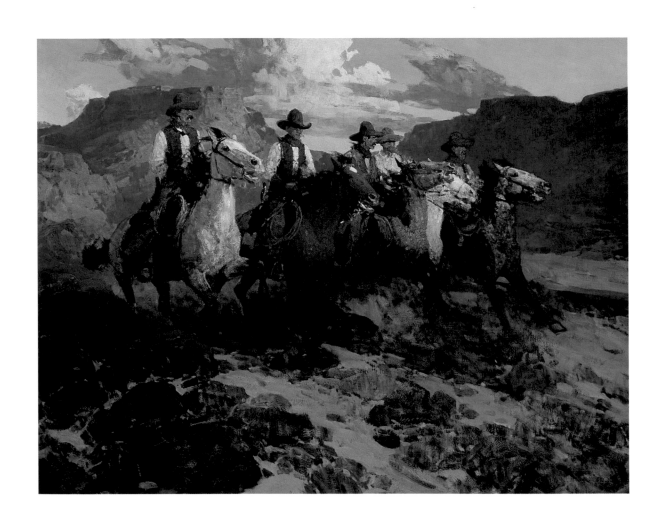

WALTER UFER

(LOUISVILLE, KENTUCKY 1876-SANTA FE, NEW MEXICO 1936)

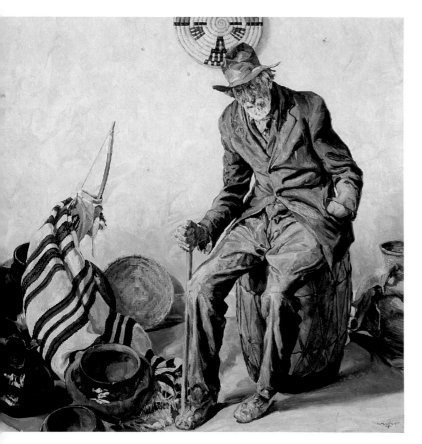

59. **Manuel la Jeunesse** (1922), oil on canvas, 50-1/4 x 50-1/4"

Back in Chicago in 1913, Ufer sought to establish his reputation as a fine artist. His work attracted the attention of Chicago mayor, Carter H. Harrison, who was a serious art collector. In 1914 the mayor offered to sponsor Ufer on an extended painting trip to Taos, New Mexico. The artist returned to paint there over the next three years. In 1917 he was elected to membership in the Taos Society of Artists. Ufer later settled in Taos and began painting out-of-doors. He claimed that studio work dulled the palette and the artist's mind. His palette lightened in the process. In his study of the New Mexican landscape, he continued to explore the contrasts of sunlight and shade which became a trademark of his work.

In addition to variety in the landscape, northern New Mexico also offered a wealth of interesting human subjects. *Manuel la Jeunesse* (1922), who posed for Ufer, was the proud descendant of one of New Mexico's seventeenth-century Spanish immigrant colonists. In *Paint and Indians* (1923) the artist portrays himself with some of his favorite Indian models. This painting was exhibited at the National Academy of Design in 1923.

Upon discovering his son's penchant for art, Ufer's father, a German engraver of gunstocks, apprenticed him to a lithographer. In 1893 when the lithographer returned to his native Hamburg, Ufer followed. He worked first as a journeyman lithographer and then studied art in Hamburg. He continued his studies at the Royal Academy in Dresden. By 1900 he had established himself in Chicago as a commercial artist and portrait painter. In 1911 he returned to Europe for further study in Munich under Walter Thor.

60. **Paint and Indians** (1923), oil on canvas, 46 1/2 x 50 1/2"

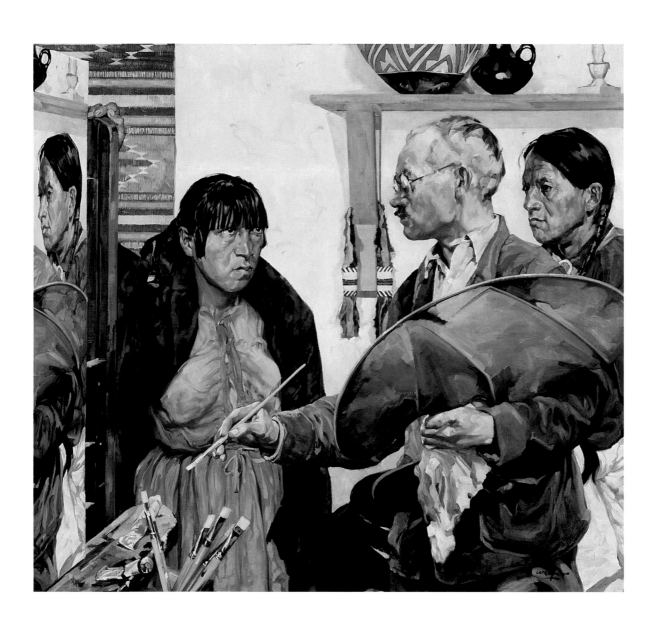

MARSDEN HARTLEY

(LEWISTON, MAINE 1877-ELLSWORTH, MAINE 1943)

Hartley's talent was first recognized when a local teacher organized an exhibition of his drawings. He won a scholarship to the Cleveland School of Art. In 1899 he moved to New York and studied under William Merritt Chase and F. Luis Mora. The following year he enrolled in classes at the National Academy of Design.

His early work (1907-1908) was characterized by a bright, impressionistic palette, which had become more somber by the time he exhibited at Alfred Stieglitz's Gallery 291 in 1909. With financial support from Stieglitz, Hartley traveled to Europe in 1919 where he was influenced by the Cubists in Paris and by members of the Blaue Reiter group in Germany.

In 1918 Hartley sought new impetus for his work. He decided to accept the invitation of socialite Mabel Dodge to visit Taos, New Mexico. While he had trouble adjusting to the altitude and the Taos art scene, which he considered outdated, he was attracted to the "magnificent" and "austere" landscape. He used vibrant blue green, brown and gold pastels to capture the light and organic shapes of the curvilinear landscape. Hartley derived inspiration from the Indian dances and from the local Hispanic *santos* (saints), which resulted in a series of still-life paintings based on these sacred images.

After 1920 Hartley did not work in the Southwest, but when he went back to Germany in 1922 he began painting his recollections of the region. They bear no resemblance to the fresh, lustrous pastels done on location — instead they depict the New Mexico landscape as a vast, wind-swept void. The mood of these paintings is one of desolation and turmoil, as seen in *New Mexico Recollections, Number 15* (1922-1923). The mountains have been reduced to undulating forms, creating a turbulent landscape. The somber colors underscore the overall brooding quality.

61. *New Mexico Recollections, Number 15* (1922-1923), *oil on canvas, 23 x 41"*

GERALD CASSIDY

(COVINGTON, KENTUCKY 1869-SANTA FE, NEW MEXICO 1934)

Upon recognition of his childhood drawing talent, Cassidy began study under Frank Duveneck at Cincinnati's Institute of Mechanical Arts. Duveneck encouraged the young artist to learn lithography, and as a result Cassidy worked for a commercial lithographic firm, continuing with his art studies at night. He later joined his brother Asa, also a lithographer, in New York and became known as one of the profession's best commercial lithographers.

In 1898 Cassidy went west in order to recover from tuberculosis. He interrupted his art career and traveled to the dry climate of Albuquerque where he entered a sanatorium. As his health improved, he spent time living and working among the Indians. Following his recovery he worked as a commercial artist in Denver for a while before returning to New York. There he resumed his art studies at the National Academy of Design and the Art Students League.

Cassidy returned to New Mexico in 1912. He settled there and played an active role in establishing the Santa Fe art colony. His mural, *The Cliff Dwellers of the Southwest* (1915), won him recognition at the Panama-California International Exposition in San Diego. In the 1920s, Cassidy received commissions for large historical works. Two of his most impressive murals, originally painted for the old Oñate Theater in Santa Fe, now hang in that city's United States Post Office. He made his first painting trip abroad in 1926-1927 and encountered some of the American artists and writers — Adolf Dehn, Ernest Hemingway and Irving Stone — who worked in Paris following the war. After six months in Paris, he traveled to England, Austria, Italy, Sicily and Tunisia.

In 1933 he exchanged his painting, *Pueblo Priestess*, with the Santa Fe Railway for an excursion to Death Valley. It was his last painting trip. A year later, while working on a commission for the federal building in Santa Fe, he was overcome by fumes and died.

Cassidy is best known for his paintings of Indians and landscapes of the Southwest. He witnessed and photographed many Indian ceremonies.

In *The Buffalo Dancer* (circa 1924) he depicts one of the participants in the hunting rituals typical of some of the Rio Grande Pueblos. In this lively composition Cassidy uses vitality of line and bold color to capture the essence of the dance.

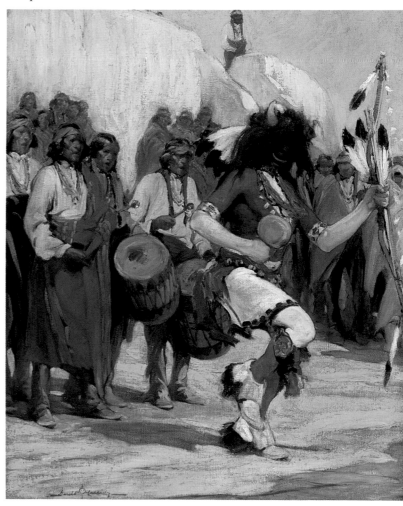

62. **The Buffalo Dancer** (circa 1924), oil on canvas, 57 x 47"

CARL OSCAR BORG

(OSTER-BYN-OSTRA, SWEDEN 1879-SANTA BARBARA, CALIFORNIA 1947)

Basically self-taught, Borg was apprenticed as a housepainter-decorator in Vanersborg from 1894 to 1899. He then worked briefly for a ship painting firm in Stockholm. In 1900 Borg accepted a job in London painting portrait and marine paintings and working as a scene painter at the Drury Lane Theatre.

In 1902 Borg traveled first to New York and then to Philadelphia in search of work. He found employment carving furniture and became a skilled woodcarver. In 1904 he settled in Los Angeles where he established himself as a photographer and sign painter. He also painted sets for the fledgling film industry. Borg's career advanced rapidly when he met art dealer William Cole and *Los Angeles Times* art critic, Antony Anderson in 1905. A year later he met Charles Lummis, editor of the *Land of Sunshine* magazine and promoter of the history and culture of the West, who was responsible for Borg's interest in Indians.

Borg met with Phoebe Hearst, who became his patroness in San Francisco. In 1910 she sponsored him for four years' study in Europe and North Africa. The purpose of this trip was to expose the artist to Old Master paintings and to new European art trends. While there he gained the required European reputation and exhibited widely in major European art centers.

Upon his return to San Francisco in 1916, Mrs. Hearst arranged for Borg to photograph and paint the Hopi and Navajo tribes. She showed her faith in Borg's abilities, observing: "Your hand is strong enough to paint and your eyes clear enough to see these twilight gods. The West needs a painter who understands the Indian soul." In order to fulfill Mrs. Hearst's commission, Borg traveled that year to New Mexico and Arizona. He was to return to the region over the next fifteen years. Subsequently Indian paintings and southwestern landscapes became the artist's principle subjects.

From 1918 to 1925 Borg lived in Santa Barbara where he painted and participated in numerous exhibitions. He taught classes at the Santa Barbara School of Arts and was accepted into the art circle there which included artists Thomas Moran and Edward Borein. From 1925 to 1930 Borg lived in Hollywood where he worked for United Artists Studios while continuing to visit and paint Indians and southwestern landscapes. Borg's disillusionment with the West and the world in general, which was undergoing changes that were contrary to the artist's value system, brought on his restless years in the 1930s. During this time he traveled widely throughout the western states, to New York and three times to Sweden. In 1938 he moved to Sweden and stayed there until war's end in 1945 when he returned to the United States to settle in Santa Barbara.

Commissioned by the Santa Fe Railway, *The Niman Kachinas* (1926) shows Borg's masterful handling of his Indian subject. This painting depicts the moment when the sacred dance has ended and the dancers have removed their masks.

63. **The Niman Kachinas** (1926), oil on canvas 47 x 54"

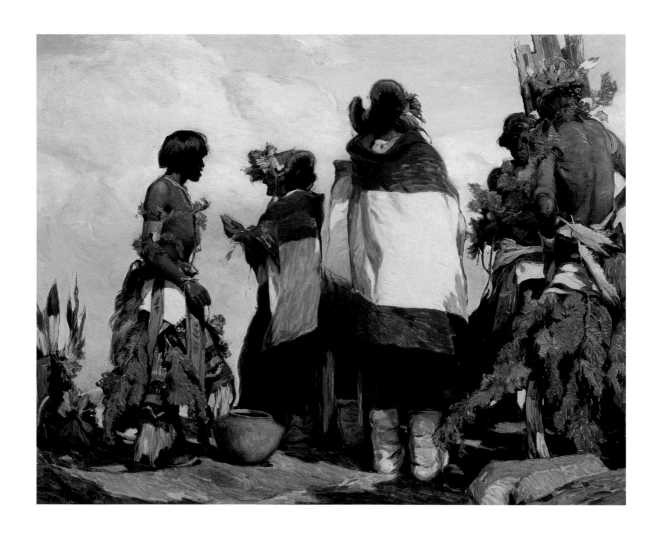

NICOLAI FECHIN

(KAZAN, RUSSIA 1881-SANTA MONICA, CALIFORNIA 1955)

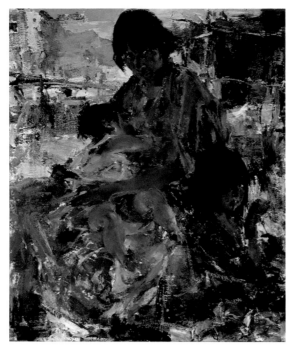

*64. **Indian Woman with Children** (1926),*
oil on canvas, 36 x 30"

Nicolai Ivanovich Fechin was born to a carpenter in the old Tatar capital of Kazan. Because of his frail constitution, his parents felt him unsuited to hard physical work. They enrolled him in the Art School of Kazan where he studied for five years. He excelled there and went to Petrograd (as Leningrad was called then), to take the entrance examinations at the Academy of Arts. As a hard-working and gifted draftsman, his success there was inevitable. Ilya Repin, one of the greatest painters and teachers in Russia at that time, was his principal instructor and the main influence on his art. Throughout his life, Fechin applied the lessons he had learned from Repin. After his years at the Academy, he developed his own individual painting technique and use of color. His canvases were boldly executed and national in character.

In 1908 Fechin returned to Kazan to teach at the Art School. There he finished his graduation

canvas and was awarded an Academy scholarship and a trip to France and Italy. In 1916 he was elected to membership in the Academy of Arts.

Fechin had many admirers in the United States. In 1923 the American Relief Administration and a number of influential collectors helped bring Fechin and his family to the United States, outside the official immigration quota. He immediately began winning awards at the National Academy of Design in New York, and had a one-man show at the Brooklyn Museum. He was courted by dealers and by other artists who wished to study with him.

However, a recurrence of tuberculosis in 1926 caused him to leave New York for the hot, dry climate of New Mexico. In 1927 he gladly accepted an invitation from John Young-Hunter to move to Taos, New Mexico. Mabel Dodge Luhan rented rooms to the Fechins until they were able to buy their own home, which Fechin remodeled and decorated to suit his fancy.

Fechin loved Taos. It is generally thought that he did his best and most productive work there, utilizing Indians and Hispanics as subjects. *Indian Woman with Children* (1926) is a powerful painting of a Taoseña mother with two small children, one nursing at her breast and the other glaring defiantly at the viewer. *Indian Summer* (1929-1933) is an opulent, autumnal still life expressing Fechin's virtuosity.

*65. **Indian Summer** (1929-1933), oil on canvas, 30 x 36"*

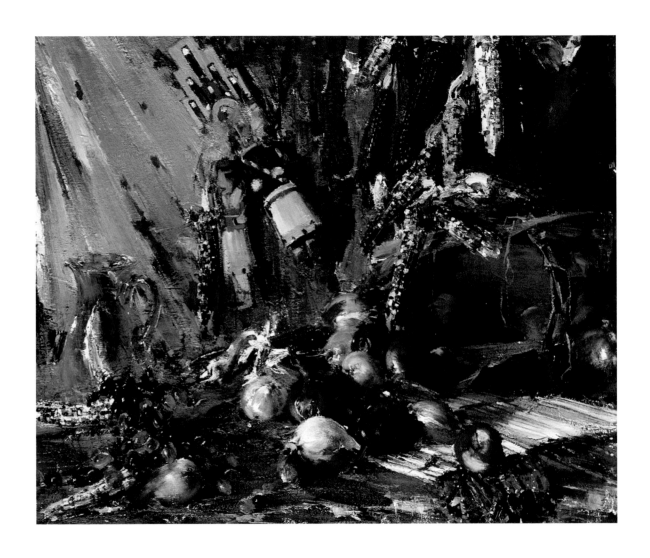

GEORGE WESLEY BELLOWS

(COLUMBUS, OHIO 1882-NEW YORK, NEW YORK 1925)

Bellows' artistic talents were evident from the time he was in kindergarten. He studied at Ohio State University and worked summers as a cartoonist with a Columbus newspaper before enrolling at the New York School of Art in 1904. Robert Henri was his teacher there, and he also studied with John Sloan.

Henri inspired his students to record urban life. Bellows captured its vigorous side, painting pictures of prize fighters, lovers in the park and drunks. Through Sloan, Bellows became aware of the plight of the urban poor and first learned from him about socialism and anarchism. Bellows later carried on the legacy of Henri and Sloan when he taught at the Art Students League. He was renowned for both his painting and his lithographic work, and his book illustrations were considered outstanding.

In 1917 Bellows spent a month with Robert Henri in Santa Fe. Although he witnessed the San Geronimo Fiesta in Taos, and took in much of the countryside, he was most fascinated by the adobe architecture of the communal pueblos and the distinctive churches. In *Pueblo, Tesuque, Number One* (1917) Bellows applies the bright colors and bold brushwork that were his trademark even at this early stage of his career.

66. *Pueblo, Tesuque, Number One* (1917), *oil on canvas, 34 x 44"*

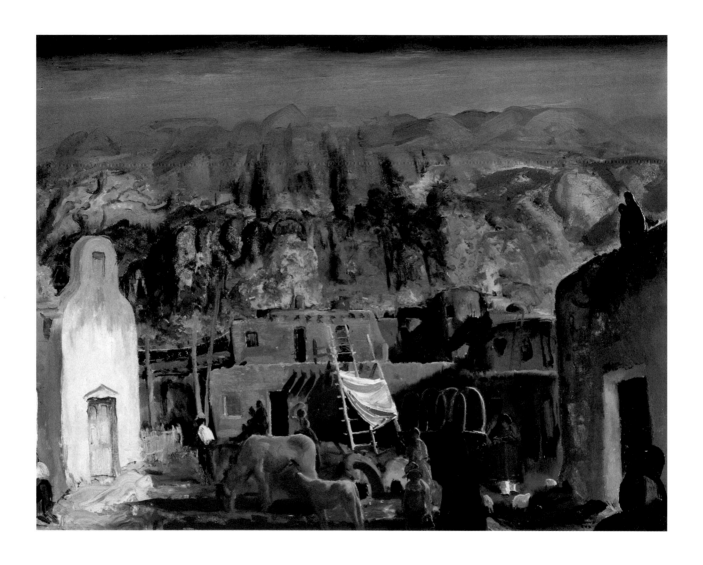

LEON GASPARD

(VITEBSK, RUSSIA 1882-TAOS, NEW MEXICO 1964)

Gaspard was introduced early on to nomadic life and the colorful Kirghiz, Kalmuck and Kazakh tribesmen of Central Asia. As a boy, he accompanied his father on extended trips to the steppes to buy furs and rugs. Later, after studying art with a Greek painter in Vitebsk, he persuaded his father to send him to Paris where he enrolled at the Académie Julian and worked as Adolphe Bouguereau's assistant. The latter was also Gaspard's mentor, and in 1906 helped arrange his pupil's first exhibition.

Gaspard married in 1909 and took his bride back to his homeland. There the couple made a two-year journey on horseback that took them as far as Irkutsk in Siberia. Returning to Paris, the artist turned his Russian sketches into paintings which he exhibited in the Paris Salon and in several other French cities.

At the outbreak of World War I in 1914, Gaspard enlisted in the French Aerial Corps, was shot down and suffered severe injuries. In 1916, after he was well enough to travel, he set off to rejoin his wife in New York. Some time later he took his doctor's advice and traveled to the arid climate of Santa Fe, New Mexico for further convalescence. There Gaspard discovered the small village of Taos. He was captivated by the region, feeling the same affinity for the landscape and the colorful Indian peoples of New Mexico that he had for his native Russia and the tribesmen of the steppes. In 1919 he made Taos his permanent home.

In 1921 Gaspard made a three-year excursion through Asia. Again on horseback, he journeyed to Mongolia, to Urga in Outer Mongolia, and then on to Siberia. He continued to central Asia up the Himalayas to Tibet, and then to China, ending his 3,000-mile journey in Peking. He made other trips — to North Africa in 1932 and back to Europe and Russia in 1959 — but spent most of his years in Taos.

Indian ceremonies fascinated Gaspard. He visited the Navajo reservation and sketched the events of pueblo life. *San Geronimo Fiesta* (1929-1953) reflects the artist's attraction to the native costumes and pageantry. He captures them with the lively brushwork and vibrant palette that characterizes his work.

67. San Geronimo Fiesta (1929-1953), oil on canvas, 29-1/2 x 30-1/2"

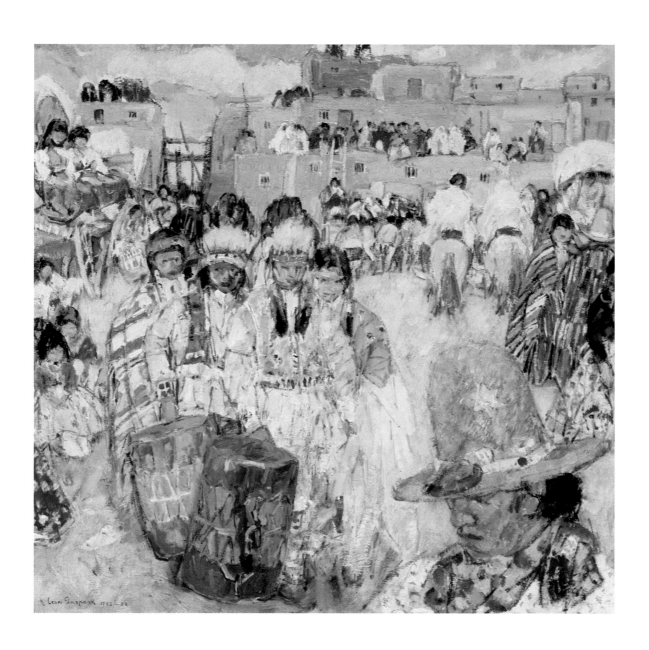

NEWELL CONVERS WYETH

(NEEDHAM, MASSACHUSETTS 1882-CHADDS FORD, PENNSYLVANIA 1945)

Wyeth attended the Eric Pape School of Art in Boston before beginning study at the Howard Pyle School of Art in Wilmington, Delaware. At age twenty, Wyeth was one of a select few chosen to study with Howard Pyle, "the father of modern American illustration," who was considered the prevailing master of his day. Wyeth displayed talent from the start and demonstrated his ability to meet the stringent requirements of illustration Pyle placed on his students. Among them were imagination, artistic ability, a sense of color and drawing, intelligence and earnestness of purpose. Beyond teaching his theories of illustration, Pyle imparted to his pupils the importance of an artist's intimate knowledge of the subject he is painting. With the help of his teacher and mentor, Wyeth went out west to familiarize himself with the frontier.

In 1904 *Scribner's Magazine* provided the young artist with transportation in exchange for the material he would gather for illustration work on western subjects. Wyeth immersed himself in the life of the West. While a cowpuncher at the Hashknife Ranch in Colorado, he participated in a roundup which he described as "the wildest and most strenuous three weeks in my life." He visited Indian reservations in Arizona, photographed and sketched the Navajo people, and slept in their hogans. Later that year Wyeth returned to Delaware with sketches of ranch and Indian life, costumes and accessories which became props in his paintings. *Outing Magazine* financed a second trip west in 1906 — this time to Grand County, Colorado — to gather information on mining engineering. Wyeth threw himself into the experience, riding on the work train where he served as a fireman.

The paintings which resulted from his western travels helped establish Wyeth's reputation with publishers and the public. He portrayed western life almost exclusively from 1904 to 1909, and then moved away from western themes to illustrate and paint historical and local subjects.

While in the West, Wyeth learned about using color and the effect of light in painting. His mastery of these aspects is evident in the vibrant, shimmering hues of *Blue Lock, the Queen* (1916), an illustration for a story of the same title published in *Collier's Weekly Magazine* (October 21, 1916). In this scene the wild horse rescues the man she has befriended, while the sheriff swings his rifle in desperation, making a last-ditch attempt to prevent the outlaw's escape.

*68. **Blue Lock, the Queen** (1916), oil on canvas, 32-1/4 x 40"*

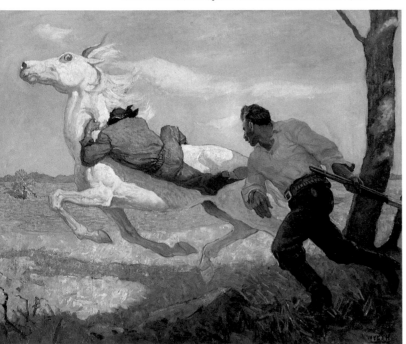

LEON KROLL

(NEW YORK, NEW YORK 1884-NEW YORK, NEW YORK 1974)

Kroll received encouragement from artist Winslow Homer to make a career of art. He studied in New York, first at the Art Students League with John Henry Twachtman and then at the National Academy of Design. He won the National Academy's scholarship for two years of study in Paris at the Académie Julian, where he continued his training under Jean-Paul Laurens.

After his return to New York, Kroll's style of painting took on a new aggressive and enthusiastic realism. This won him recognition and brought him success. From 1912 on Kroll won awards in important national exhibitions, such as First Prize at the

Carnegie Institute's International Exhibition. He was a participant in the New York Armory Show of 1913. Kroll taught painting classes in some of the nation's leading art schools, among them New York's National Academy of Design and the Art Students League, and the Pennsylvania Academy of Fine Arts in Philadelphia.

Kroll was associated with the Henri circle. The presence of Robert Henri and George Bellows in New Mexico brought Kroll to Santa Fe in 1917. The paintings he did were predominantly landscapes. They reflect his enthusiasm for the wide sky and the vast panoramas. *Santa Fe Hills* (1917) has the lightness and touch of a watercolor, and proves Kroll's facile handling of the southwestern landscape.

69. **Santa Fe Hills** (1917), oil on canvas, 26-1/4 x 32-1/4"

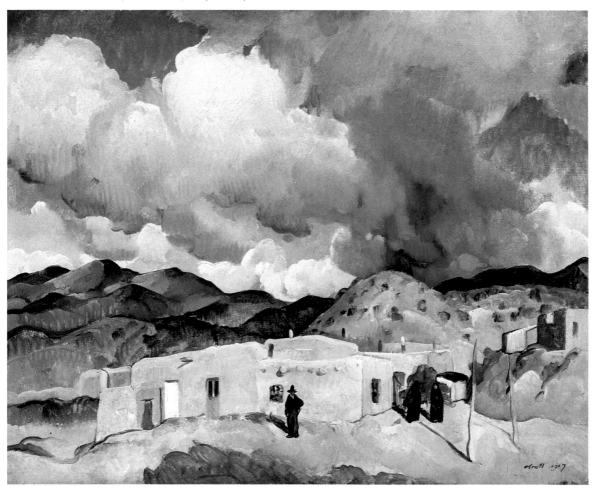

VICTOR HIGGINS

(SHELBYVILLE, INDIANA 1884-TAOS, NEW MEXICO 1949)

With his family's support, Higgins began his art studies at the Art Institute of Chicago when he was fifteen years old. In 1910 his desire for further training took him to Europe. In Paris he studied at the Académie de la Grande Chaumière under René Menard and Lucien Simon, and later in Munich under Hans von Hayek. While in Paris, Higgins met Walter Ufer. They shared a mutual antipathy toward academic subject matter and lamented the lack of international recognition for American art.

Upon his return to Chicago in 1913, he met Chicago Mayor Carter H. Harrison. In 1914 the mayor sponsored Higgins on a painting trip to Taos, New Mexico. He spent the next years commuting between Chicago and Taos, and finally moved to the northern New Mexico village in 1920.

The fresh pictorial qualities of Taos stimulated him. He wrote that the West was composite and fascinating. It had an architecture that he considered the only naturally American one. He was attracted to the diverse landscape of New Mexico and to its Anglo, Hispanic and Indian peoples.

In Higgins' early New Mexico work, he came to grips with the landscape by brightening his palette to capture the brilliant light. By 1917 the artist had emerged with his own definitive artistic style and began to create a series of masterpieces which brought him recognition.

In the 1920s, Higgins' style was characterized by fluid brushwork and a flattened, nearly abstract simplicity. His landscapes were rendered in broad strokes of rich pigment. In *Pueblo of Taos* (before 1927), considered his most important work from this period, the artist captures the light, space and mood of his subject through an interrelationship of forms and movement within the composition. He presents the Indians, reduced to slabs of color, in an architectural setting framed by the landscape.

*70. **Pueblo of Taos** (before 1927), oil on canvas, 43-3/4 x 53-1/2"*

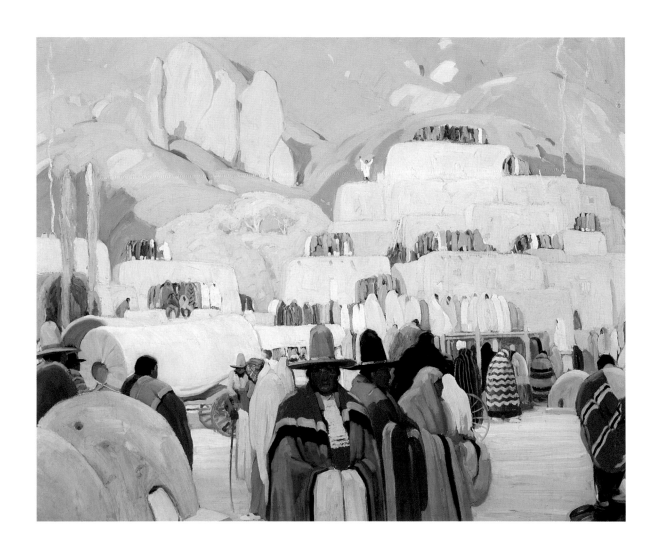

E. MARTIN HENNINGS

(PENNS GROVE, NEW JERSEY 1866-TAOS, NEW MEXICO 1956)

Hennings decided to become an artist after visiting the Art Institute of Chicago in 1899. Two years later he enrolled as a full-time student at its school and graduated with honors in 1904. Over the next two years he attended additional classes there. He began his career as a commercial artist and painted murals and portraits in the Chicago area until 1912.

In 1912 Hennings went to Europe to study at the Royal Academy in Munich. Walter Thor and Franz von Stuck were among his teachers. Following the outbreak of World War I, the artist returned to Chicago in 1915. There Hennings taught at the Academy of Fine Arts of Chicago and continued to work as a commercial artist.

In 1917 the artist travelled to Taos, New Mexico for the first time under the sponsorship of Carter H. Harrison, mayor of Chicago. Hennings visited Taos for several months and in 1921 decided to make his permanent home there. This move occasioned a burst of new creative energy in his work which led to awards at numerous exhibitions in the ensuing years. In 1924 he was invited to join the Taos Society of Artists and remained an active member until the group disbanded in 1927.

New Mexico had a profound influence on Hennings' work. Like other artists painting in the region, he responded to the brilliant southwestern light by brightening his palette. He was also inspired by the variety of scenic richness in northern New Mexico. In his notes he expressed his enchantment with the area:

I have been working in Taos for many years and I think that should prove that I like it here; the country, the mountains with their canyons and streams, the sage beneath the clouded skies, the adobe village with its Spanish people and of course the Taos Pueblo with its Indians. Their life — domestic and agricultural — with all the color and romance of their dress and history.

In the painting, *Taos Plaza in Winter* (alternately titled *The Hitching Post in Winter*, mid-1930s), Hennings depicts the town's three distinct cultures — Native American, Hispanic and Anglo. This painting is typical of the artist's work in its rich hues and masterful interplay of light and shadow.

*71. **Taos Plaza, Winter** (mid-1930s), oil on canvas, 34 x 40"*

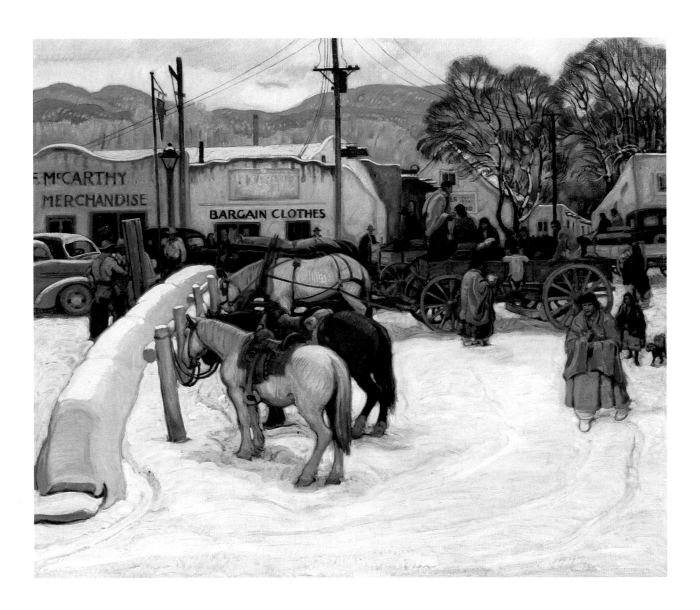

GEORGIA O'KEEFFE

(SUN PRAIRIE, WISCONSIN 1887-SANTA FE, NEW MEXICO 1986)

Determined to pursue a career in art, O'Keeffe studied at the Art Institute of Chicago from 1904 to 1905. In 1907 she enrolled at the Art Students League of New York where she studied with William Merritt Chase. Although she won prizes for her work, O'Keeffe was discouraged with her progress and gave up painting for some years.

In 1912 Alon Bement recognized her talent and hired her to teach at the University of Virginia. That autumn she took a position for two years as supervisor of art in the public schools of Amarillo, Texas. O'Keeffe's teaching duties left little time for either painting or her own artistic development. The fall of 1915 marked a turning point in her career. She realized that her work showed only the influence of others and nothing of herself. She set aside all of her previous training and embarked on the creative course which evolved into her highly personal style. Her drawings from this period were inspired more by emotion than by nature. Nearly all of them were abstract. Her watercolors were broad and free, utilizing simple strong forms and harsh colors.

O'Keeffe sent some of her watercolors to a friend with strict instructions not to let anyone else see them. The friend showed O'Keeffe's works to

*73. **Another Church, Hernandez, New Mexico** (1931), oil on canvas, 10 x 24"*

Alfred Stieglitz, who in turn exhibited them at his Gallery 291 in New York. The year was 1916 and it marks the beginning of Stieglitz' life-long professional and personal association with O'Keeffe.

By 1924, the year of her marriage to Stieglitz, O'Keeffe had broadened her artistic language. She began painting representational subjects taken from nature. She often painted in series. In 1929 O'Keeffe visited Taos as the guest of Mabel Dodge Luhan. There she was inspired by the play of light and shadow and began to extract and simplify forms. After Stieglitz' death in 1946, she made New Mexico her permanent home.

O'Keeffe's southwestern work was dominated by the landscape and the architecture. In *Another Church, Hernandez, New Mexico* (1931), she simplifies forms and captures the simple dignity of this southwestern structure. *Red Hills, Grey Sky* (1935), one of a series on this subject, shows the artist's fascination with the land. She expressed her feelings for the landscape in an exhibition catalog (1939): "A red hill doesn't touch everyone's heart as it touches mine and I suppose there is no reason why it should.... You have no associations with those hills — our waste land — I think our most beautiful country."

*72. **Red Hills, Grey Sky** (1935), oil on canvas, 14 x 20"*

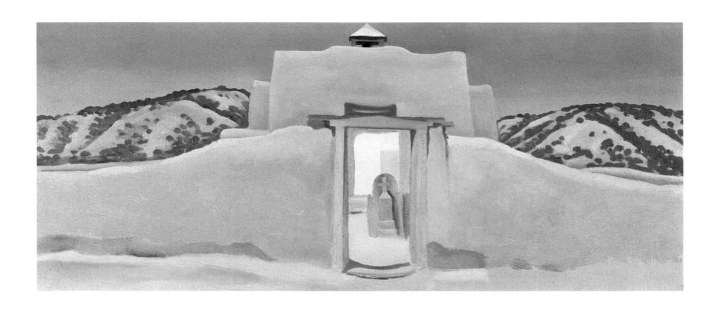

LAVERNE NELSON BLACK

(VIOLA, WISCONSIN 1887-CHICAGO, ILLINOIS 1938)

Black displayed an interest in drawing horses and Indians at a young age. When the family moved to Chicago in 1906, the young artist began study at the Chicago Academy of Fine Art where he was a student from 1906 to 1908. The ensuing ten years Black worked as a newspaper artist in Chicago and briefly in New York. During this period he continued painting and worked in bronze. A tribute to the high quality of his bronzes came when they were chosen for exhibit at Tiffany's in New York.

Due to ill health Black moved in the late 1920s to the dry climate of the Southwest and settled in Taos, New Mexico. The artist produced some of his best work inspired by the light, the landscape and the colorful inhabitants of the region.

Failing health caused Black's resettlement to the small desert community of Phoenix, Arizona. Throughout the 1920s and 1930s Black completed several commissions for the Santa Fe Railway which hung his paintings in the company's largest offices. In 1937 the Federal Art Project selected Black's mural proposal for the United States Post Office in Phoenix. While working on this commission, Black contracted a kind of paint poisoning which eventually caused his death.

In *Buffalo Dance* (before 1931), which was commissioned by the Santa Fe Railway, Black combines Taos subjects — the Sangre de Cristo Mountains, the pueblo architecture and the picturesque Pueblo Indians — and depicts them using the broad blocks of color typical of his style.

*74. **Buffalo Dance** (before 1931), oil on canvas, 40 x 49"*

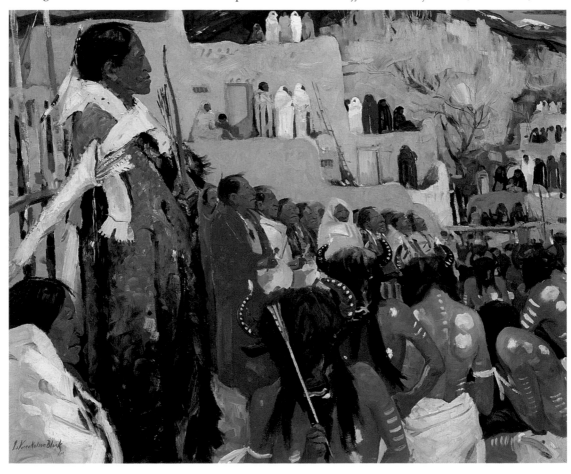

WINOLD REISS

(KARLSRUHE, GERMANY 1886-NEW YORK, NEW YORK 1953)

Born into an artistic family, Reiss's earliest studies were with his father, whose artistic mission was to record the German landscape and its peasants. In order to receive a more formal education, he traveled to Munich sometime between 1911 and 1913. There he studied under Franz von Stuck at the Academy of Fine Arts and under Julius Diez at the School of Applied Art.

The Wild West stories of German author, Karl May, and the novels of James Fenimore Cooper, fueled in Reiss the desire to see and depict Native Americans. With this intent, he immigrated to the United States in 1913 and settled in New York. There he became known for his book and magazine illustrations. His work appeared in *Scribner's, Century, Architectural Forum* and other leading national periodicals. He also designed Art Deco commercial interiors ranging from murals and design for such ventures as the Restaurant Longchamps (both in New York and in Washington, D. C.) and the Hess Brothers restaurant in Allentown, Pennsylvania to mosaics for the Cincinnati Union (Train) Terminal. In 1915 he opened the Winold Reiss Art School in New York and four years later held the school's first summer session in Woodstock, New York. He kept the school open until 1940 when his move to a smaller studio no longer accommodated classes.

In the winter of 1919 Reiss took the first of several trips to Browning, Montana, to study and draw the four tribes of Blackfeet Indians — Siksika or Northern Blackfeet, the Blood, and the North and South Piegan. He produced 36 portraits following this excursion, and began the first of many national and international exhibitions of his portrait series. Following in his father's footsteps, Reiss proceeded to record first Indian and then other ethnic groups. For example, in 1920 he traveled to Mexico and drew the descendants of the Aztecs. In 1923 he was chosen to portray the major figures of the Harlem Renaissance by the editor of *Survey Graphic*. Like Charles Bird King before him, Reiss's portraits are among the few comprehensive surveys documenting multicultural America in his time.

From 1919 to 1943 Reiss traveled intermittently to Montana to depict the Blackfeet people who lived there. In July 1927 Great Northern Railroad sponsored Reiss' study trip to Glacier National Park, Browning, Montana, and Alberta, Canada.

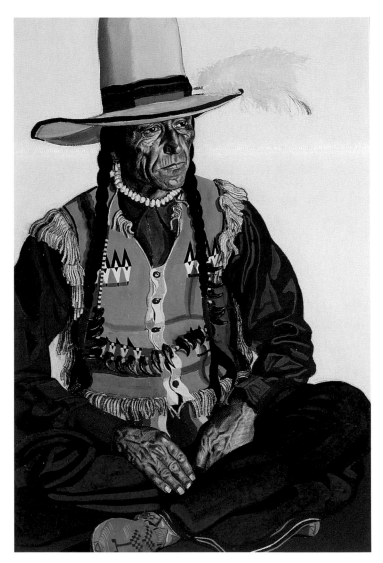

75. **Plume** (circa 1927-1928), mixed media, 39-1/2 x 26-1/2"

Throughout the 1930s and 1940s, Reiss continued to paint portraits for the Great Northern's collection, some of which were used on the railroad's calendars. One of these portraits was of *Plume* (Blackfeet name *Kia'nah 'ke-wan*, circa 1927-1928), a Blood medicine man, also known as "Bird Rattler."

THOMAS HART BENTON

(NEOSHO, MISSOURI 1889-KANSAS CITY, MISSOURI 1975)

Benton studied at the Corcoran Gallery of Art in Washington, D. C. from 1896 to 1904 and then at the Art Institute of Chicago from 1907 to 1908. He departed for Paris where he spent the next three years studying at the Académie Julian and the Académie Colorossi. He later abandoned formal classes in order to conduct his own study of the masterpieces in the Louvre. During this time he experimented with Impressionist techniques under the tutelage of American artist, John Thompson, and associated with other artists then living in Paris, among them John Marin, Jo Davidson and Diego Rivera.

In 1911 Benton returned to the United States and spent a brief time in Neosho and Kansas City before moving to New York in June of the following year. He began exhibiting his work and in 1919 participated in the Forum Exhibition of Modern American Painters at Anderson Gallery along with other New York modernist painters.

From 1918 to 1919, Benton served as an architectural draftsman for the United States Navy during World War I. After the war he returned to New York where in 1921 he began work on his first mural project, a study of American history entitled *American Historical Epic*. This was the first of numerous mural projects that the artist was commissioned to paint over the next forty-two years. He completed the first five panels between 1923 and 1924 and the second five between 1925 and 1926. Benton's murals brought him national recognition. In 1933 The Architectural League of New York awarded him a gold medal in tribute to his decorative painting.

In 1926 Benton began teaching at New York's Art Students League. He was an instructor there until 1935 when he left to direct classes at the Kansas City Art Institute.

Benton's move back to the Midwest was a turning point in his career. He began to portray a specific region concentrating on capturing its unique local quality while simultaneously depicting its universal aspects. Benton had met John Steuart Curry and Grant Wood in the early 1930s, and had discovered their shared belief that the artist should paint the "spirit of a place." Their art was later termed "regionalism" when art critic Thomas Craven began advocating the American Scene movement, whose painters rejected foreign artistic influence and con-

centrated on expressing the spirit of America. Benton was the movement's most articulate artist, and together with Curry and Grant, he was responsible for elevating regionalist imagery to national stature.

In the late 1920s Benton had traveled from New York to the South and the Midwest. In the 1950s and 1960s he explored the western wilderness, sometimes on horseback to get to remote areas. His explorations of the majestic western landscape culminated in equally monumental canvases. *Wheat Threshing on the High Plains* (1969) grew out of sketches the artist made in Wyoming in 1950. As in his other paintings of the West, Benton was influenced by the light and bright colors of the region, which is shown in the high color key he employs in this painting.

76. ***Wheat Threshing on the High Plains*** *(1969), oil on canvas, 17-1/2 x 33-1/2"*

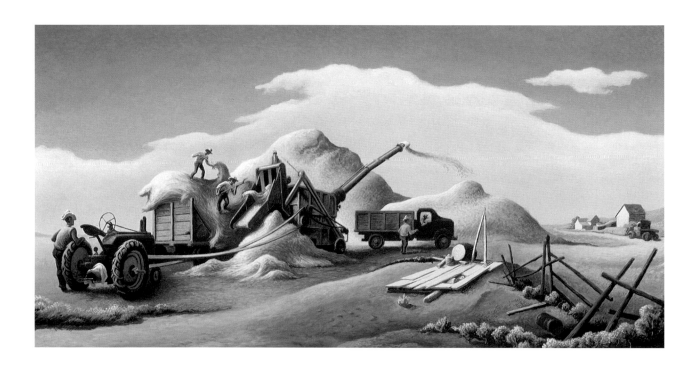

DEAN CORNWELL

(LOUISVILLE, KENTUCKY 1892-NEW YORK, NEW YORK 1960)

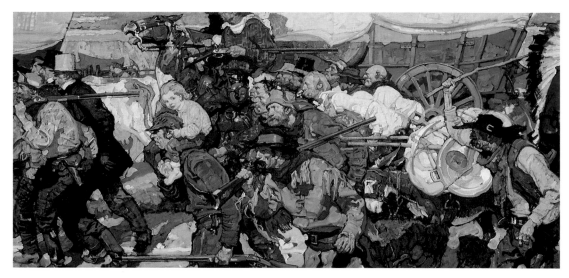

*77. **Days of the '49ers** (1926), oil on canvas, 32 x 68"*

Cornwell's parents, who were both artistic, encouraged their son's early talents. Due to his father's occupation as a civil engineer, drawing supplies were always at hand. He inherited his mother's love of nature and her ability to observe and identify plant species. His parents not only praised and critiqued his efforts at drawing, perspective and composition, but also provided most of his early art training.

Determined to become a newspaper illustrator, Cornwell drew cartoons for *The Louisville Herald* in exchange for tickets to the musicals he depicted. His persistence paid off and the newspaper hired him on full time. In 1911 Cornwell set off for Chicago where he worked as staff artist for two Chicago newspapers until 1915, when he moved to New York to study with Harvey Dunn. He also took classes at the Art Students League.

From 1916 to 1927 Cornwell devoted his energy to book and magazine illustration. In 1919 Cornwell began a long and successful career with Hearst Publications. Throughout the 1920s and 1930s his illustrations appeared in *Cosmopolitan*, *Harper's Bazaar*, and other periodicals. That same year he achieved artistic acclaim when he won First Prize for Illustration at the Wilmington Society of Fine Arts. Three years later he won the Chicago Art Institute's Award of Merit. Desiring to learn a more permanent form of artistic creation than illustration could provide, Cornwell determined to master mural painting. He had always admired the work of

British artist, Frank Brangwyn, and in 1927 arranged to study with him in England. He spent the next three years absorbing mural techniques from Brangwyn. As a result his work became more decorative and stylized. Shortly after his return to the United States in 1930, Cornwell launched his 30-year career as a muralist with a commission from the Los Angeles Public Library. From then on Cornwell considered mural painting his true calling and relied on his illustrations to generate income.

Cornwell's ancestors had been among Kentucky's earliest settlers. Proud of his pioneer heritage, the artist devoted time to studying the settlement of the frontier within the scope of American history. He had many assignments to illustrate stories about the West. These he researched carefully in order to lend historical authenticity to his paintings. Cornwell painted *Days of the '49ers* (1926) to illustrate "The Days of '49," a story which appeared in the October 1926 issue of Hearst's *Cosmopolitan* magazine.

HAROLD VON SCHMIDT

(ALAMEDA, CALIFORNIA 1893-WESTPORT, CONNECTICUT 1982)

Von Schmidt showed an interest in illustration at age seven. He studied at the California College of Arts and Crafts from 1912 to 1913 and at the San Francisco Art Institute from 1915 to 1918. During this time he also studied with California artist Maynard Dixon, who was Von Schmidt's mentor and with whom he opened a business in 1917 known as Advertising Illustrators, an endeavor that lasted four years. In 1924 Von Schmidt went east to study under Harvey Dunn, a leading American illustrator. Dunn's teaching, which encouraged painting the epic rather than the incidental, greatly influenced Von Schmidt. He soon received commissions from major national magazines, among them *Collier's*, *Cosmopolitan* and *The Saturday Evening Post*. His association with the latter lasted twenty years.

During World War I, the artist designed posters for the Navy. In World War II he served as artist-correspondent in both the European and Pacific theaters. Later he was in Korea and the Far East on an assignment for the Air Force.

Von Schmidt served as president of the New York Society of Illustrators and was a founder and instructor of the Famous Artist School in Westport, Connecticut, along with Norman Rockwell and other distinguished American illustrators. In recognition of his talents, the United States Post Office commissioned him to design the stamp commemorating the Pony Express.

In his early years as an artist Von Schmidt sketched and painted the California Sierras and other picturesque California landscapes. Although he lived in the East the last four decades of his life, he always thought of himself as a Westerner. He commented on working in the out-of-doors: "I draw and paint outdoors, not to make easel paintings, but to acquire experience and knowledge as reference for both the form and color of a locale and the people who live there or travel through it."

Von Schmidt's favorite subjects were the sea and the Old West. As a young man Von Schmidt had worked on cattle drives and heard stories of the frontier as related by his '49er grandfather. *Trading Post* (1937) was used as an illustration for an article of the same name in the October 30, 1937 issue of *Saturday Evening Post*. The subject is Bent's Fort on the Arkansas River in Colorado. One of the Bent brothers, in the painting the seated figure wearing Indian accoutrements, married into the Cheyenne Indian tribe.

*78. **Trading Post** (Bent's Fort, Colorado) (1937), oil on canvas, 23-1/8 x 53"*

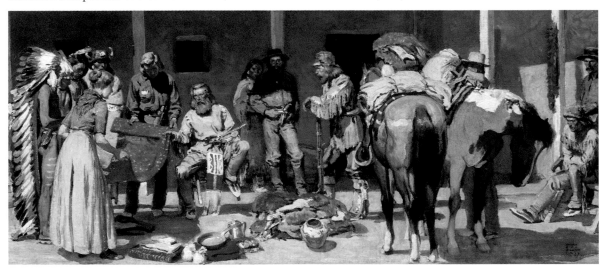

STUART DAVIS

(PHILADELPHIA, PENNSYLVANIA 1894-NEW YORK, NEW YORK 1964)

Stuart Davis met members of what later constituted "The Eight" when he was a child in Philadelphia. His father, who was art director for the *Philadelphia Press*, commissioned illustrations from John Sloan, William Glackens, George Luks and Everett Shinn. In 1910 Davis attended Robert Henri's school in New York City. The young artist absorbed the ideas of modernism advocated by "The Eight" and later sent works to the Independent Artists exhibition in New York. In 1913 Davis did some illustrations for *Harper's* and *The Masses*, a socialist periodical. That year he exhibited in the Armory Show.

At John Sloan's invitation, Davis visited New Mexico in the summer of 1923. His landscapes were semi-realistic, much in the manner of Marsden Hartley. *New Mexico Landscape* (1923) is typical of the artist's style of that period. He applies cubistic flattening, pointillist dots and heavily applied outlines to arrive at his short-hand version of pictorial representation. Davis was disappointed in New Mexico. In his opinion it was "too picturesque"— a place for an ethnologist rather than an artist. The artist's stay in New Mexico marked a stylistic turning point. The landscapes he painted there were among the last which were recognizable and non-fractured.

After his return to New York, Davis had his first one-man exhibition. In 1927 he began his Eggbeater series. He taught at the Art Students League from 1931 to 1932. A year later, he enrolled in the Public Works of Art Project which was incorporated into the Works Progress Administration (WPA) in 1935. Davis worked in the WPA mural and graphics division until 1939. From 1940 to 1950 he taught at the New School for Social Research in New York. Over the next two decades his work received recognition both in the United States and abroad. His paintings won awards and were exhibited in one-man shows and retrospectives in leading American museums and at international venues,

such as the Tate Gallery in London (1946), the Biennale in Venice (1956) and the American National Exhibition in Moscow (1959).

A leading American modernist, Davis' artistic career spanned seven decades and embraced every major artistic development from the realism of the Ashcan School to "Synthetic Cubism" to pop art. During this time he kept extensive notebooks which probed the nature of art and are a key to understanding his *oeuvre*. In the last four decades of his life, Davis's geometric compositions stimulated new developments in American modernism.

79. **New Mexico Landscape** (1923), oil on board, 15 x 24"

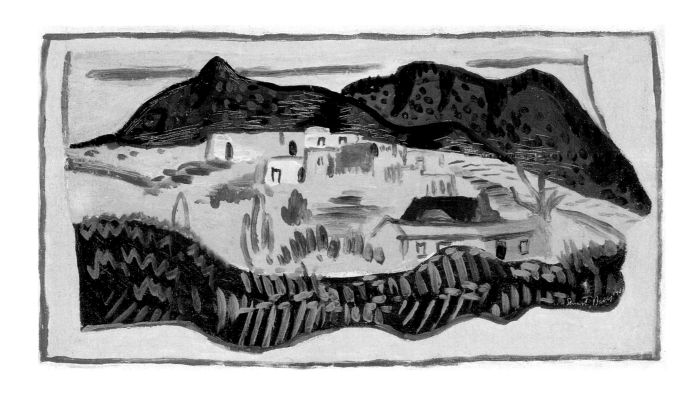

EMIL BISTTRAM

(HUNGARY 1895-TAOS, NEW MEXICO 1976)

Born in a village near the Hungarian-Romanian border, Bisttram immigrated with his family to the United States in 1906. He enrolled in night classes at the National Academy of Design, the Cooper Union and other art schools. He also studied with artists Leon Kroll and Jay Hambidge, who advocated Dynamic Symmetry, a theory of mathematical relationships in art. Bisttram stated that he owed his success to the concepts of Dynamic Symmetry which allowed "the artist to create order out of chaos."

In 1920 Bisttram began teaching at the Parsons School of Design. He taught there until 1925 when Nicholas Roerich, founder of the Master Institute of United Arts, asked him to teach fine art classes. The school's mission was to bring various branches of the fine arts together under one roof. It's motto: "Art will unify all humanity. Art is one — indivisible. Art has many branches, yet all are one." Bisttram's experience with Roerich impacted him spiritually. He devoted the rest of his life to translating art into a spiritual and visionary language.

Bisttram won a Guggenheim Fellowship in 1931 and obtained permission to work with Diego Rivera in Mexico City. His stay there lasted only a few months. He returned to the States and settled in Taos, New Mexico in 1932. That same year he opened the Taos School of Art and introduced the community to the tenets of Dynamic Symmetry. His school, which eventually drew students from all over the United States, was renamed the Bisttram School of Fine Art in 1943. Beginning in 1941 the artist also conducted classes over a ten-year period first in Phoenix and then in Los Angeles. Bisttram continued teaching in Taos until 1965.

Under the United States government's Treasury Relief Art Project (TRAP), Bisttram was commissioned to paint murals in the Taos Court House. In 1933-1934 he was appointed supervisor of TRAP in New Mexico. Bisttram's mural commission for the Justice Department Building in Washington, D. C. brought him national recognition. He later received government commissions for murals in Roswell, New Mexico (1936) and Ranger, Texas (1937).

Bisttram was instrumental in founding the first art gallery in Taos in 1933. He also provided the leadership for creating the Taos Art Association around 1952, where he succeeded in gathering artists from both the representational and the modernist camps.

An important event in Bisttram's career transpired in 1938 when he and Raymond Jonson founded the Transcendentalist Painting Group. With nine other artists working in diverse styles, the group created art that "transcended" to a higher plane through the vehicle of abstract and non-objective forms, which culminated in a sort of intellectual art.

Bisttram experimented with many painting styles. Rivera's influence is clearly discernible in *Consolation* (1932). The painting was inspired by a real-life situation that Bisttram witnessed driving from Santa Fe to Taos.

*80. **Consolation** (1932), oil on canvas, 52 x 52"*

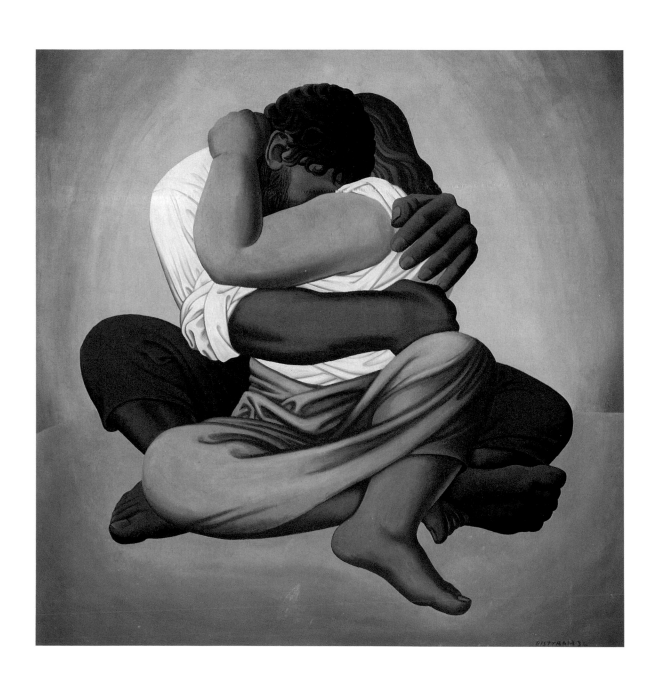

FLETCHER MARTIN

(PALISADE, COLORADO 1904-GUANAJUATO, MEXICO 1979)

As a child, Martin determined to become an
artist but had no opportunity to pursue this interest.
After a mixed career as a harvest hand, lumberjack
and professional boxer, and a stint in the United
States Navy, Fletcher Martin began to devote him-
self to painting. He received a federal mural assign-
ment in the 1930s. In 1934 he held his first exhibition
at the Fine Arts Gallery in San Diego. He taught
painting at the Art Center School in Los Angeles in
1938 and 1939, and he was the Artist-in-Residence at
the University of Iowa in 1940 and 1941.

During World War II, Martin was an artist-
correspondent for *Life Magazine*. After the war he
taught at the Art Students League in Woodstock,
New York from 1947 to 1949. He had a visiting pro-
fessorship at the University of Florida from 1949 to
1952. Then he returned to New York City where he
worked as an illustrator and commercial artist. In
later years he made his home in Guanajuato,
Mexico.

Martin's paintings are known for their strong
design and stylized, linear treatment of typically
American subjects. The rodeo is an American insti-
tution and *July 4th, 5th and 6th* (1940) conveys the
excitement and action of a timed rodeo event called
"bulldogging." Done at the time that the artist was
employed on mural projects, this is probably
a mural study.

81. ***July 4th, 5th and 6th*** *(1940), oil on canvas, 40 x 55"*

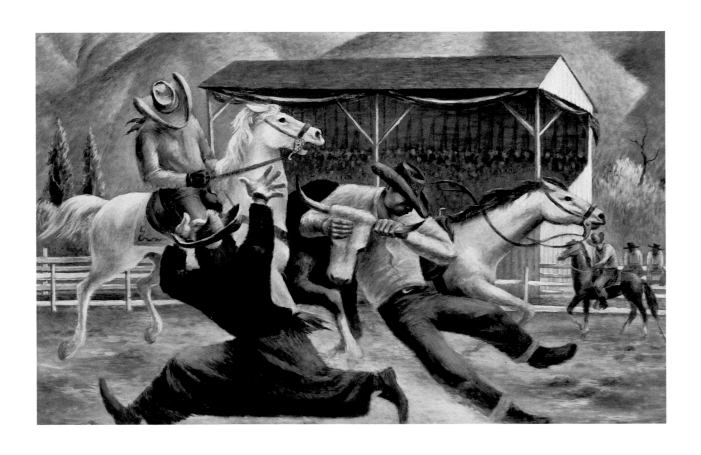

JACKSON POLLOCK

(CODY, WYOMING 1912-EAST HAMPTON, NEW YORK 1956)

Pollock spent his childhood and adolescence in Wyoming, Arizona and California. His first exposure to the arts occurred in Los Angeles where he attended classes at Manual Arts High School until 1929. That year he left Los Angeles to enroll at the Art Students League in New York. He studied under Thomas Hart Benton and adopted his mentor's dynamism and vigorous compositional technique. The Mexican muralists, David Alfaro Siquieros and José Orozco, also influenced Pollock's work at this time, as did Picasso and the European surrealists after 1935.

Employment on the Federal Arts Project in 1935 brought Pollock little success, but in 1942 his luck changed. Robert Motherwell introduced him to Peggy Guggenheim, who in turn commissioned a large-scale painting and signed him on with her gallery. Clement Greenberg, art critic for *The Nation* and the spokesman for the *avant garde*, praised and championed his work.

In 1946 Pollock abandoned figurative painting and produced his best-known works. The most famous of these are the so-called "drip paintings," achieved by pouring the paint from the can directly onto the canvas. By 1949 Pollock was one of the leading painters of his time. He had a strong influence on the younger generation of painters who regarded him as a master.

For some months during 1928 and 1929 he assisted his father and brother on geological surveys of the Grand Canyon and regions of Arizona and California. His exposure to the wide open spaces of the West translated into an intense preoccupation in his later work with vast spaces resulting in colossal compositions. *Man, Bull, Bird* (1938-1944) shows the influence of the West in both the subject matter and the choice of southwestern colors. The painting is typical of Pollock's output between 1937 and 1946 which denotes a synthesis of cubism and surrealism.

*82. **Man, Bull, Bird** (1938-1941), oil on canvas, 24-1/2 x 36-1/2"*

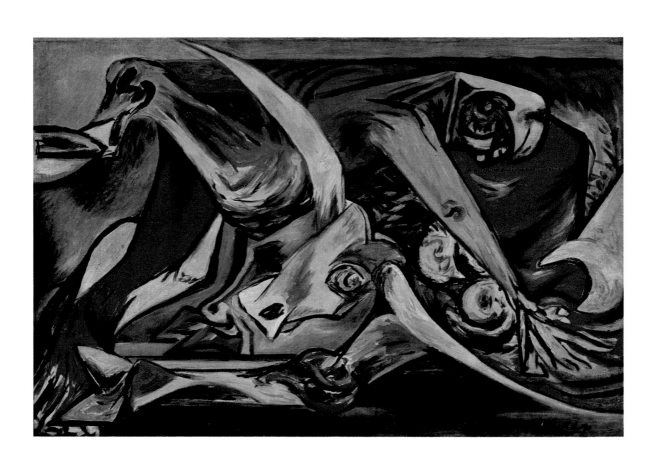

R. BROWNELL McGREW

(BORN COLUMBUS, OHIO 1916-LIVING IN SOUTHERN ARIZONA)

McGrew studied under Ralph Holmes at the Otis Art Institute in Los Angeles. In 1947 he won a Stacey Fellowship which permitted him a year's intensive study of landscape painting. He was drawn to paint first in the California Sierras and then in the desert. McGrew decided to devote most of his energy to desert painting, and described its artistic challenge:

You can find any kind of combination in the desert, any sort of relationship or composition which you can or can't imagine. There is a great difference in natural colors in the desert which you can't find anywhere else. The browns and grays which elsewhere are just browns and grays are full of a thousand colors here.

Around 1960, influenced by California artist James Swinnerton, McGrew abandoned landscape painting for a while in favor of painting Native Americans. By publishing some of his Indian subjects, *Desert Magazine* further encouraged the artist's new direction. McGrew spent a period sketching, painting and living among the Navajo and Hopi. Like many artists of the West who preceded him, he developed a love and compassion for these people and their customs, rituals and lifestyles. While the Hopi and Navajo have been a continuing source of fascination for McGrew, he has also been drawn to resume landscape painting in the Southwest, particularly in Arizona, Utah and the desert land of southern California. He too preserved an era which has since passed. McGrew was the last artist of the twentieth century to experience the "old days" of the Hopi and Navajo, when these people still traveled by horse and wagon and when many of them spoke only their native languages.

Like many of his large group paintings, *At the Sing* (1968-1969), is a composite of elements drawn from widely separated times and regions. The location of the "sing" is the Monument Valley area, located near the Arizona-Utah border. This painting typifies the unique quality McGrew terms "luminosity which is the mingling of color for opalescence." He achieves this effect by priming pressed-board with a white lacquer undercoat, laying in the paint with linseed oil and turpentine, often sealing the intermediate layers with shellac. After the painting dries, he applies one heavy coat of damar varnish.

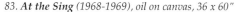

*83. **At the Sing** (1968-1969), oil on canvas, 36 x 60"*

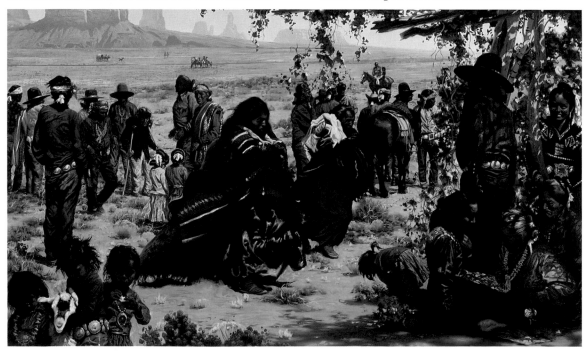

FRITZ SCHOLDER

(BORN BRECKENRIDGE, MINNESOTA 1937-LIVING IN SCOTTSDALE, ARIZONA)

Demonstrating artistic talent as a youngster, Scholder studied with Sioux Indian painter, Oscar Howe, in Pierre, South Dakota from 1951 to 1954. He later took painting and art history classes at Sacramento City College in California and studied with Wayne Thiebaud. In 1961 Scholder was awarded a full two-year scholarship to participate in the Rockefeller Foundation's Southwest Indian Art Project.

In 1964 Scholder began teaching advanced painting and contemporary art history at Santa Fe's new Institute of American Indian Arts. He fostered his students' respect for their own heritage and taught them to treat the Indian subject in painting as individual rather than as stereotyped, romanticized figures.

In 1967 Scholder began his Indian series and became the leader of an Indian painting movement. He stated that a new and vital Indian art was emerging which would merge traditional subject matter with the contemporary idiom to provide a truer statement about the Indian. This sentiment is echoed in *An American Portrait* (1979) which blends the traditional with the contemporary.

In 1980 Scholder ended his Indian series, and challenged all Indian painters to stop painting Indian subjects. In this he was fighting his own categorization as an Indian painter. He felt that the art critics and media had mislabeled him, and that "a true artist evolves every day and shouldn't be relegated to a category."

In 1969 Scholder began painting full-time. He traveled to North Africa and Europe. While in London he saw the work of the English modernist, Francis Bacon, which led him to paint harsh, ironic distortion into his canvases for a time. In 1970 he began his lithographic career, producing a suite entitled "Indians Forever" for the Tamarind Institute, a lithography studio in Albuquerque, New Mexico. His subsequent involvement with lithography workshops throughout the United States and Europe included the renowned Mourlot Workshop in Paris. In 1973 Scholder was named Artist-in-Residence at Dartmouth College and in 1985 was recipient of the Golden Plate Award from the American Academy of Achievement, of which he is now a patron.

Scholder's concern with cliches about women led a to series on female nudes in 1978 which

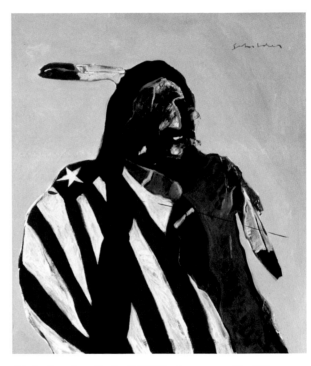

84. An American Portrait (1979), oil on canvas, 40 x 35"

later evolved into the "Mystery Women." Besides women, Scholder is constantly working on other series. Over the last two decades he has developed, among others, "Shamans," "Dream Horses," "Mysteries (Egypt)" and "Possession."

His newest series, "Humans in Nature," derives from his interest and involvement in ecology. These paintings feature single human figures standing alone in a landscape of chaos.

INDEX

PAST EXHIBITIONS

Boise Gallery of Art Boise, Idaho
26 April-16 June 1974

Utah Museum of Fine Arts
Salt Lake City, Utah
30 June-7 September 1974

National Cowboy Hall of Fame
Oklahoma City, Oklahoma
15 September-15 November 1974

Museum of New Mexico
Santa Fe, New Mexico
9 December 1974-2 February 1975

Wichita Art Association
Wichita, Kansas
9 February-7 April 1975

El Paso Museum of Art El Paso, Texas
8 September-20 September 1976

Phoenix Art Museum Phoenix, Arizona
21 January-6 March 1977

Glenbow-Alberta Institute
Calgary, Alberta, Canada
15 March-1 June 1977

The Fine Arts Gallery of San Diego
San Diego, California
1 October-13 November 1977

University Art Museum Austin, Texas
University of Texas at Austin
11 December 1977-6 February 1978

Joslyn Art Museum Omaha, Nebraska
20 May-2 July 1978

Chrysler Museum Norfolk, Virginia
17 January-28 February 1979

National Academy of Design
New York, New York
10 July-15 September 1979

Buffalo Bill Historical Center
Cody, Wyoming
5 October-30 November 1979

Fine Arts Museum of the South
Mobile, Alabama
3 January-20 February 1980

Helsingin Taidetalo Helsinki, Finland
27 August-5 October

Gilcrease Institute Tulsa, Oklahoma
21 October 1980-5 January 1981

Princeton University Art Museum
Princeton, New Jersey
25 January-15 March 1981

Corcoran Gallery of Art
Washington, D. C.
25 March-26 April 1981

Musées Royaux des Beaux-Arts
de Belgique Brussels, Belgium
15 May-28 June 1981

Museum of Chinese History
Beijing, People's Republic of China
19 November 1981-19 January 1982

Shanghai Art Museum
Shanghai, People's Republic of China
19 February-19 March 1982

Münchner Stadtmuseum
Munich, West Germany
26 January-26 April 1982

The Mall Galleries London, England
3 June-3 July 1982

Musée Jacquemart-Andre Paris, France
15 November-15 December 1982

Museum des 20. Jahrhunderts
Vienna, Austria
20 January-13 March 1983

Portland Art Museum
Portland, Oregon
9 September-6 November 1983

Palm Springs Desert Museum
Palm Springs, California
18 November-24 December 1983

Society of the Four Arts
Palm Beach, Florida
7 January-5 February 1984

Brooks Memorial Art Gallery
Memphis, Tennessee
10 March-29 April 1984

New Orleans Museum of Art
New Orleans, Louisiana
8 May-15 July 1984

Museum of the Southwest
Midland, Texas
31 August-28 October 1984

Columbus Museum of Art
Columbus, Ohio
9 December 1984-27 January 1985

Tucson Museum of Art
Tucson, Arizona
16 February-21 April 1985

The Rockwell Museum
Corning, New York
11 July-2 September 1985

Portland Museum of Art
Portland, Maine
18 September-3 November 1985

American Museum of Natural History
New York, New York
29 November 1985-16 February 1986

Honolulu Academy of Arts
Honolulu, Hawaii
27 March-4 May 1986

Birmingham Museum of Art
Birmingham, Alabama
24 August-19 October 1986

Arkansas Art Centeyr
Little Rock, Arkansas
14 November 1986-11 January 1987

Sierra Nevada Museum Reno, Nevada
26 September-8 November 1987

Crocker Art Museum
Sacramento, California
18 July-7 September 1987

Lakeview Museum of Arts and Sciences
Peoria, Illinois
2 May-28 June 1987

The Museum of Fine Arts, Houston
Houston, Texas
21 February-19 April 1987

Oklahoma Art Center
Oklahoma City, Oklahoma
20 November 1987-20 February 1988

High Museum of Art Atlanta, Georgia
8 March-1 May 1988

University Art Museum
Laramie, Wyoming
20 August-16 October 1988

Gene Autry Western Heritage Museum
Los Angeles, California
28 January-26 March 1989

San Antonio Art Museum
San Antonio, Texas
10 April-4 June 1989

State Tretyakov Gallery
Moscow, U.S.S.R.
29 June-9 August 1989

Regional Art Gallery
Novosibirsk, U.S.S.R.
24 August-22 October 1989

Georgian State Art Museum
Tbilisi, U.S.S.R.
2 November 1989-10 February 1990

Museum of Fine Arts
Santa Fe, New Mexico
19 May-16 September 1990

Utah Museum of Fine Arts
Salt Lake City, Utah
21 October-16 December 1990

Fresno Metropolitan Museum
Fresno, California
16 January-24 March 1991

Wichita Art Museum Wichita, Kansas
14 April-11 August 1991

SELECTED BIBLIOGRAPHY

Allen, Douglas. *Majesty and Wilderness: Work by Carl Rungius*. Corning, NY: Rockwell Museum, 1985.

Arkelian, Marjory Dakin. *William Hahn: Genre Painter 1829-1882*. Oakland,CA: Oakland Museum, 1976.

_____. *Thomas Hill: The Grand View*. Oakland, CA: Oakland Museum, 1976.

Baigell, Matthew. *Thomas Hart Benton*. New York: Abrams, n.d.

Baird, Joseph A. *The West Remembered; Artists and Images, 1837-1937: Selections from the Collection of Earl C. Adams*. San Francisco: California Historical Society, 1973.

Bickerstaff, Laura M. *Pioneer Artists of Taos*. Denver: Old West, 1983.

Bowman, John S., ed. *The World Almanac of The American West*. New York: Ballantine, 1986.

Breeskin, Adelyn D. and Rudy H. Turk. *Scholder/Indians*. Flagstaff, AZ: Northland Press, 1976.

Broder, Patricia Janis. *Dean Cornwell: Dean of Illustrators*. New York: Balance House, 1978.

_____. *Taos: A Painter's Dream*. Boston: New York Graphic Society, 1980.

Cechetti, Philip Alan & Don Whittemore. *Art America: A Resource Manual*. New York: McGraw-Hill, 1977.

Chappellier Galleries. *Herman Herzog: 1831-1932*. New York, 1974.

Clark, Carol. *Thomas Moran: Watercolors of the American West*. Ft. Worth, TX: Amon Carter Museum, 1980.

Coke, Van Deren. *Taos and Santa Fe: The Artist's Environment, 1882-1942*. Albuquerque: University of New Mexico Press, 1963.

Cosentino, Andrew J. *The Paintings of Charles Bird King (1785-1862)*. Washington, D. C.: Smithsonian Institution Press, 1977.

D'Emilio, Sandra. "E. Martin Hennings: Watching the Ceremony" in *Southwest Art*, October 1986.

Duff, James H. *The Western World of N. C. Wyeth*. Cody, WY: Buffalo Bill Historical Center, 1980.

Dwight, Edward H. *Worthington Whittredge (1820-1910): A Retrospective Exhibition of an American Artist*. Utica, NY: The Widtman Press, 1969.

Ebersole, Barbara. *Fletcher Martin*. Gainesville: University of Florida Press, 1954.

Eldredge, Charles C., Julie Schimmel & William H. Truettner. *Art in New Mexico, 1900-1945: Paths to Taos and Santa Fe*. New York: Abbeville for National Museum of American Art, 1986.

Fees, Paul and Sarah E. Boehme. *Frontier America: Art and Treasures of the Old West from the Buffalo Bill Historical Center*. New York: Abrams, 1988.

Frankenstein, Alfred. *After the Hunt: William Harnett and Other American Still Life Painters 1870-1900*. Berkeley and Los Angeles: University of California Press, 1953.

Goetzman, William H. and Joseph C. Porter. *The West as Romantic Horizon*. Omaha: Joslyn Art Museum, 1981.

Goetzmann, William H. & William N. Goetzmann. *The West of the Imagination*. New York: Norton, 1986.

Goheen, Ellen R. *Thomas Hart Benton: An American Original*. Kansas City: Nelson-Atkins Museum of Art, 1989.

Groce, George C. and David H. Wallace. *The New-York Historical Society's Dictionary of Artists in America: 1564-1860*. New Haven, CT: Yale University Press, 1974 (rev. ed.)

Grubar, Francis S. *William Ranney: Painter of the Early West*. Washington, D. C.: Corcoran Gallery of Art, 1962.

Haskell, Barbara. *Marsden Hartley*. New York: Whitney Museum of American Art, 1980.

Hassrick, Peter H. *Carl Rungius: Western Wildlife*. Cody, WY: Buffalo Bill Historical Center, 1977.

_____. *The Way West: Art of Frontier America*. New York: Abrams, 1977.

Hassrick, Peter H., et al. *American Frontier Life: Early Western Paintings and Prints*. New York: Abbeville, 1987.

Heltunen, Vicki and Roger Rak. *Color, Pattern & Plane: E. Martin Hennings in Taos*. Orange, TX: Stark Museum of Art, 1986.

Hendricks, Gordon. *Albert Bierstadt: Painter of the American West*. New York: Abrams, 1974.

Hogarth, Paul. *Artists on Horseback: The Old West in Illustrated Journalism, 1857-1900*. New York: Watson Guptill, 1972.

Hoopes, Donelson F. *Alexander Pope, Painter of "Characteristic Pieces"*, The Brooklyn Museum Annual, Vol. VIII, 1966-67.

Horan, James D. *The Life and Art of Charles Schreyvogel: Painter-Historian of the Indian-Fighting Army of the American West*. New York: Crown, 1969.

_____. *The McKenney Hall Portrait Gallery of American Indians*. New York: Crown, 1972.

Hough, Katherine Plake, et al. *Carl Oscar Borg: A Niche in Time*. Palm Springs, CA: Palm Springs Desert Museum, 1990.

Hughes, Edan Milton. *Artists in California: 1786-1940*. San Francisco: Hughes, 1986.

J. Golden Taylor, ed. *A Literary History of the American West: Sponsored by the Western Literature Association*. Fort Worth: Texas Christian University Press, 1987.

Jacobowitz, Arlene. *Edward Henry Potthast 1857 to 1927*. New York: The Chapellier Galleries, 1969.

Kirkland, Forrest. *The Rock Art of Texas Indians*. Austin: University of Texas Press, 1967

Lamar, Howard R. (ed.). *The Reader's Encyclopedia of the American West*. New York: Thomas Y. Crowell Company, 1977.

Landau, Ellen G. *Jackson Pollock*. New York: Abrams, 1989.

Lawall, David B. *A. B. Durand*. Montclair, NJ: Montclair Art Museum, 1971.

Ludwig, Coy. *Maxfield Parrish* New York: Watson-Guptill, 1973.

Malone, Michael P. (ed.). *Historians and the American West*. Lincoln: University of Nebraska Press, 1983.

Malone, Michael P. and Richard W. Etulain. *The American West: A Twentieth Century History*. Lincoln: University of Nebraska Press, 1989.

McCracken, Harold. *The Frank Tenney Johnson Book*. Garden City, NY: Doubleday, 1974.

McGrew, R. Brownell. *R. Brownell McGrew*. Kansas City: Lowell, 1978.

Milton, John R. *The Novel of The American West*. Lincoln, NE: University of Nebraska Press, 1980.

Nash, Gerald and Richard W. Etulain (editors). *The Twentieth Century West: Historical Interpretations*. Albuquerque: University of New Mexico Press, 1989.

Nelson, Mary Carroll. *The Legendary Artists of Taos*. New York: Watson-Guptill, 1980.

Pagano, Grace. *Contemporary American Painting: The Encyclopaedia Britannica Collection*. New York: Duell, Sloan and Pearce, 1945.

Porter, Dean A. *Victor Higgins: an Indiana-born Artist Working in Taos, New Mexico*. Notre Dame: University of Notre Dame, 1975.

Prown, Jules David and Barbara Rose. *American Painting*. New York: Rizzoli, 1977.

Reed, Walt. *Harold von Schmidt Draws and Paints the Old West*. Flagstaff, AZ: Northland Press, 1972.

Robertson, Edna. *Gerald Cassidy 1869-1934*. Santa Fe: Museum of New Mexico, 1977.

Robertson, Edna and Sarah Nestor. *Artists of the Canyons and Caminos: Santa Fe, the Early Years*. Santa Fe: Peregrine Smith, 1976.

Samuels, Peggy and Harold. *Artists of the American West*. Norman: University of Oklahoma Press, 1968.

Shapiro, Michael and Peter H. Hassrick. *Frederic Remington: the Masterworks*. New York: Abrams for Saint Louis Art Museum and Buffalo Bill Historical Center, 1988.

Shapiro, Michael, et al. *George Caleb Bingham*. New York: Harry N. Abrams for Saint Louis Art Museum, 1990.

Smith, Mabel P. "Unpublished Paintings by Alburtis Del Orient Browere," in *Art in America*, Fall 1958.

Stewart, Jeffrey. *To Color America: Portraits by Winold Reiss*. Washington City: Smithsonian Institution Press, 1989.

Taft, Robert. *Artists and Illustrators of the Old West, 1850-1900*. New York: Scribner, 1953.

Thieme, Ulrich and Felix Becker. *Allgemeines Lexikon der Bildenden Künstler von der Antike bis zur Gegenwart*. Leipzig: Verlag von Wilhelm Engelmann, 1907.

Trenton, Pat. *Picturesque Images from Taos and Santa Fe*. Denver: Denver Art Museum, 1974.

Truettner, William H. *The Natural Man Observed: A Study of Catlin's Indian Gallery*. Washington: Smithsonian Institution Press, 1979.

Tuckerman, Henry. *Book of the Artists*. New York: Putnam, 1882.

Tuska, Jon. (ed.) *The American West in Fiction*. Lincoln: University of Nebraska Press, 1982.

Tuska, Jon & Vicki Piekarski. *Encyclopedia of Frontier and Western Fiction*. New York: McGraw-Hill, 1983.

Tyler, Ron (ed.). *Alfred Jacob Miller: Artist on the Oregon Trail*. Fort Worth: Amon Carter Museum, 1982.

Tyler, Ron, et al. *American Frontier Life: Early Western Painting and Prints*. New York: Abbeville Press, 1987.

Udall, Sharyn Rohlfsen. *Modernist Painting in New Mexico 1913-1935*. Albuquerque: University of New Mexico Press, 1984.

_____. *Santa Fe Art Colony, 1900-1942*. Santa Fe: Gerald Peters Gallery, 1987.

Van Nostrand, Jeanne. *The First Hundred Years of Painting in California, 1775-1875*. San Francisco: Howell, 1980.

Waters, Frank. *Leon Gaspard*. Flagstaff, AZ: Northland Press, 1964.

White, Robert. *The Taos Society of Artists*. Albuquerque: University of New Mexico Press, 1983.

Wiggins, Walt. *The Transcendental Art of Emil Bisttram*. Ruidoso Downs, NM: Pintores Press, 1988.

Wilmerding, John. *American Art*. New York: Penguin, 1976.

Witt, David. *Emil James Bisttram*. Taos, NM: The Harwood Foundation, 1983.

Yost, Karl and Frederic G. Renner. *A Bibliography of the Published Works of Charles M. Russell*. Lincoln: University of Nebraska Press, 1971.